MYSTERIES

of the

MAGNOLIA HOTEL

MYSTERIES

—— *of the* ——

MAGNOLIA HOTEL

ERIN O. WALLACE

THE
History
PRESS

Published by The History Press
Charleston, SC
www.historypress.com

Cover image by Llamar Vasquez of Llamar Vasquez Photography, Seguin, Texas.
Opposite: Parents of author, Marguerite "Bubbles" Semlinger Wallace (1929–2014) and Jesse "JB" Bryan Wallace (1928–2017). *Author's collection.*

First published 2018

ISBN 9781540235701

Library of Congress Control Number: 2018940091

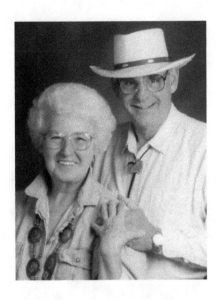

This book is dedicated to my mother, Marguerite "Bubbles" Semlinger Wallace (1929–2014). Marguerite was profoundly proud of her German heritage. Her memory of our family's journey to America, as told to her by my great-grandmother, Agnes (née Goebel) Zuercher, was sharp and accurate. I could listen to her for hours on end as she shared our ancestors' stories. Her affection for our family's history inspired me to become a genealogist, local historian and eventually a writer. She was also blessed with an amazing gift of foresight (psychic abilities). Because the company of spirits was commonplace for her, she grew contented among them. It was her teaching that spirits were simply souls yet to pass over that made it easier for me to accept their presence. It is for these reasons that I will forever be grateful to her.

CONTENTS

PREFACE

Jim and I had always dreamed about restoring a small historic old building together. Through Jim's restoration expertise and my history research and museum curator skills, we felt it would be the perfect "us" project. With our children now grown, we were looking forward to spending quality time together. When we purchased the Magnolia Hotel, we had no inkling how much our lives would be affected by it. What began as our private weekend retreat has now evolved into a fascinating new life's journey. From the day we walked through the door of this nearly two-centuries-old hotel, the world as we knew it was forever altered.

This unbelievable hotel has more history in one room than most towns have throughout their entire years. Even before we purchased this amazing building, its intense history began to unfold with the help of locals. Then, no sooner had we signed the papers, becoming the next guardians of the hotel, than paranormal experiences began to take place.

Although we were told that the building was not haunted when we agreed to purchase it, from the very first day of ownership the spirits began to let their presence be known. Doors slamming, ice-cold drafts felt during the peak of Texas summer heat, voices, footsteps and shadow figures became everyday experiences. Lights could be seen flashing on and off upstairs by passersby, although there was no electrical source. Even the exterior grounds began to reveal unusual sightings, such as several ghostly figures roaming outside the building. We would later discover via a local policeman that the last owner had called them constantly because walking could be heard on the second floor even though the building was empty.

ACKNOWLEDGEMENTS

I wish to thank my soulmate, husband and best friend in life, James "Jim" William Ghedi, for sticking by my side throughout this wild and unbelievable journey. This publication of *Mysteries of the Magnolia Hotel* would not have been a reality without his incredible support, understanding, endless patience and encouragement, all of which kept me focused. He is my sanctuary when the world around me is turning upside down. I could not have completed this project had it not been for him, and I can't imagine my life without him. Thank you, my Jimmy.

Husband of author, James "Jim" William Ghedi. *Photograph by author.*

THE JOURNEY BEGINS

The path to this unusual journey actually began after being approached by an editor at The History Press. The publisher was searching for an author who knew the history of New Braunfels and possibly a few ghost stories. It was for its popular series of books called Haunted America. The publisher had discovered that my ancestors had been one of the founding families of New Braunfels through my syndicated genealogical column. I had written several stories on how my German ancestors, the Zuerchers, arrived in Texas with the help of Prince Carl of Solms-Braunfels in 1845, and this caught its attention. As a twist, I occasionally included a few ghost stories told to me by my grandmother. The publisher's plans were to call the book *Haunted New Braunfels: A True Wild West Ghost Town*. With my knowledge background, I qualified for what it was seeking.

At first, I was a little apprehensive writing an entire book about such an unconventional subject. Oh, I knew a great deal about the town's history through my mother's stories, so that was no problem. But it was my grandmother's ghost tales I wasn't completely confident of. Although I believed my grandmother's stories to be true, it was important to at least confirm some legitimacy to them. Let's face it: we were talking about ghost stories here. The best I could do was a little research before sharing, so I did just that. I waited a few weeks before agreeing while I did some double-checking on these tall tales of hers. After thoroughly researching her leads, I discovered that they were indeed factual.

The Zuerchers, the author's ancestors and one of the founding families of New Braunfels. *Author's collection.*

The stories of these peoples' deaths were undeniably true and actually occurred at the locations she mentioned. Although her versions stood to be true, proving that the ghosts from her stories existed was going to be a tad trickier. Being certain that the readers whose minds are open to the possibility of ghosts existing would enjoy it, I still wondered about the skeptics. Then my mom told me something that made my decision easier. She said, "Those who believe or want to believe will listen to your words. Those who do not believe won't even pick up your book. So relax and write what you know to be true. Let them make their own decisions." With those words in mind and the research complete, I finally consented to writing the book.

It was important to see these possible ghost sightings firsthand, so I made a list of my grandmother's tall tales. With the list being so lengthy and my space limited, it was necessary to be selective. The sites with the most viable information seemed the best chances, but nonetheless, I chose my favorite ghost tales first. I began with the Landa Park Ghosts, the Drowning Cowboy, the Sippel Suicide and the Buckhorn Saloon. At each location I visited, the owners were so hospitable and helpful. It felt as though they were pleased to finally be able to share their own personal ghostly accounts. Having someone listen to their stories who didn't doubt

them seemed almost comforting to them. The paranormal experiences encountered at these locations were unbelievable. These selected locations most definitely proved to have spirits still lingering within the building's walls. It was fascinating to discover this in person. What was even more thrilling was watching the owners learn of this too.

After visiting all the haunted locations and undertaking some spine-chilling paranormal investigating, the manuscript was typed up and ready to send off. With thirteen ghostly chapters fully completed, the editor still requested one more story. There were a few more leads on my list, but additional proof was needed to validate them. The local library would be the next destination to obtain more information before comfortably including them.

Once there, some old vertical files seemed to be a good start in possibly verifying one or more of my grandmother's stories. While rummaging through the stack of files, one of the library volunteers approached me. She asked if I was the woman writing a book on ghost hauntings in New Braunfels. My first thought was, "Wow, news sure travels fast in small towns." Instinctively, I thought that this might be a skeptic, so while mentally preparing to defend myself, I said, "Yes, I am." Then she said, "Oh, how fascinating! I absolutely love ghost stories! Have you considered doing a story on the Comal Town Traveling Ghost? I have always wondered who she was."

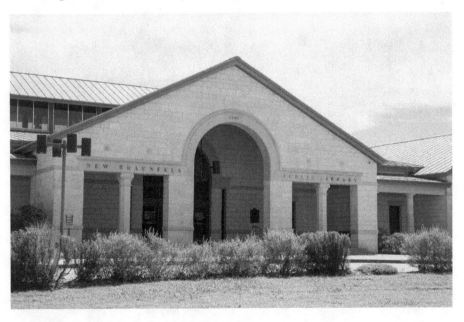

The New Braunfels Public Library. *Photograph by Megan Foster, Seguin, Texas, meganfosterphotography.com.*

Relieved that she was a believer (and, better yet, one offering a lead on a story), I told her that this was one I had not heard of. She became so giddy after my response that she practically dropped the books she was holding. Without even an invitation to do so, she swiftly grabbed an empty chair to sit beside me. After adjusting her chair, the woman slowly turned and looked me straight in the eyes. I couldn't help but notice how gentle her eyes looked. They were bluer than blue, with a deep sense of kindness. My mom always said, "A person's eyes are the windows to their soul. Always follow your intuition by what you sense." Remembering her words, I suddenly felt comfortable sitting next to this nameless stranger about to share a ghost story. However, no sooner had she begun to speak than a funny thing happened. Everything around us became quiet, near silent. It felt as if she and I were suddenly the only ones in the entire building. With each word she spoke, I became more engrossed in her story. As Jim and I look back now, we know that this mysterious woman (whose name I never did acquire) changed the course of our lives forever.

DEATH OF AN ANGEL

The woman began by saying that the story of the Comal Town Traveling Ghost had been told for generations in her family. Her great-grandfather had actually encountered the female ghost child once. I stopped her and asked, "Ghost child? This ghost is a female child?" She nodded and replied, "Oh yes, it's really very sad. This young girl spirit has been seen by locals for ages."

The woman continued. The child spirit has been seen wandering the streets of New Braunfels for years, beginning at the Comal River. She is always dressed in an antique-looking white gown with curly, shoulder-length hair. The little spirit has been seen walking from East Common Street (near the Comal Cemetery) to West San Antonio Street before the railroad tracks and around Castell Avenue. Several shops along this route have grown accustomed to her presence. People say that her visits are short-term, as though she were just checking in. Often the spirit briefly stands and smiles, but sometimes she dances or skips along the road in the early morning. If anyone tries to speak to her, she simply vanishes. Everyone agrees that she does not seem to be in distress, sad or even lost. She appears to just be enjoying her day in the same manner as any innocent young child would.

When the young woman ended her story, it left me speechless. "How sad," I told her. "This just breaks my heart." Her story actually brought tears to my eyes. As I began to reach for a tissue in my purse, the woman took hold of my hand. To this day, I remember the intense energy I felt from her hands.

"Gosh, I didn't mean to upset you," said the woman. Apologizing for my weakness, I then thanked her for sharing. When asked if she had any idea who this young child could be, she looked me right in the eyes once again and said, "No, but wouldn't it be a blessing if you could help uncover who she was and what happened to her?" She seemed incredibly sincere as she spoke. I agreed and then asked if she knew about when the spirit began to be seen. She could only speculate around 1880, since this was when her great-grandfather first shared his sighting with her family. Totally captivated by her story, I asked what her great-grandfather's name was. Before she could answer, she looked around the room as if someone were calling her. Then she suddenly sprang from her chair. "I better get back to work now. I love volunteering here. Maybe we'll meet again soon. Good luck on your findings." I thanked her profusely, and then off she went around the tall shelves of books.

That evening, I found it very difficult to fall asleep. Thoughts of the nameless woman volunteering at the library and the poor little female spirit roaming the streets were hard to shake off. I am a firm believer that there are no coincidences in life. Everything happens for a reason—everything. In my heart, I knew that the chance meeting with this woman was profound, but what did it mean? What was the reason for this unusual encounter of a stranger and the story of a young ghost? It was terrible to think that this young female spirit was still wandering the town. The desire to uncover this sweet child's death was overwhelming. The more I thought about it, the more convinced I became that she needed my assistance. Before falling asleep, I mentally promised this child to do whatever possible to help her. I had made my decision to go looking for her.

The next day, I made my way back over to the library for a second time. I wanted to ask the blue-eyed woman a few more questions I had thought of. I roamed the library searching for her for a while but was unable to locate her. Finally, I went to the front help desk to inquire about her name and see if she was coming in that day. When asked about the volunteer with the pretty blue eyes from the day before, the woman looked at me as though I was crazy. She stated that there were no volunteers assisting yesterday—only the paid staff had worked. I asked if maybe she volunteered in the book shop in front, and she stated, "Nope, that was closed yesterday." Not wanting to look like a total lunatic, I told her thanks and walked away. I could feel her still watching me all the way to the exit door. My curiosity made me go back looking for her several more times—just never at the help desk again. Oddly enough, I never was able to locate her.

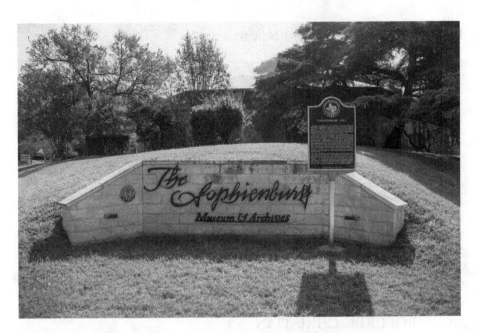

The Sophienburg Museum & Archives. *Photograph by Megan Foster, Seguin, Texas, meganfosterphotography.com.*

Now with this strong urge to uncover this young female spirit's identity, I was like a modern-day Sherlock Holmes. Ready to trace all leads, I thought New Braunfels's local museum, called the Sophienburg, might prove helpful with information on deaths around 1880.

Upon entering the building, one could not help but be in awe of this museum. There was a huge research library to the right and a rather ominous-looking museum entrance to the left. Out of curiosity, I decided to enter the museum area first. The first room was staged to give the appearance of being on the inside of a cramped ship's compartment headed to Texas. The display indeed gave the sense of being back in time alongside German immigrants traveling to a better place. To see what my own ancestors might have gone through was sad but still fascinating. After turning the first corner, I noticed a faded, inconspicuous document hanging on the wall. The small framed paper was a list of the town's original settlers. Though feeling that this list needed to be more prominent and celebrated, I was excited to see my ancestor's name, Nicolaus Zuercher. He had been given lot 142 by Prince Solms-Braunfels himself. Suddenly, a beautiful feeling of warmth and tingling emanated throughout my arms. I knew without a doubt that it was my ancestors welcoming me to the museum.

LIST OF ORIGINAL SETTLERS TO NEW BRAUNFELS

Lot No. *Name*

91.	ALBRECHT, BLASIENZ
169.	ARNOLD, JOHANN
76.	ARNOLD, PETER
16.	ASSEL, HERMANN VON
31.	BALDUS, JOHANN
26.	BAUER, ALEXIS VON
38.	BELLMER, CARL
146.	BELLMER, CARL
212.	BENE, LUDWIG
139.	BENFER, GEORG
95.	BENNER, ADOLPH
68.	BEVENROTH, HEINRICH
28.	BOECKEL, CHRISTIAN
156.	BOETTSCHER, AUGUST
279.	BOTH, JOHANN
133.	BOTHMER, HEINRICH
175.	BRACHT, VIKTOR
176.	BRACHT, VIKTOR
179.	BRACHT, VIKTOR
180.	BRACHT, VIKTOR
152.	BRASCHE, HEINRICH
153.	BRASCHE, HEINRICH
13.	BRECHER, JACOB
20.	BREILIPPER, JOH. H

Lot No. *Name*

33.	BREMER, HEINRICH C.
201.	BROCKHUYSEN, CARL
101.	BRUNS, FRIEDRICH
67.	BURG, PETER
185.	BUSSMANN, DANIEL
163.	CASPARY, JOHANN
225.	CATHOLIC CON.
252.	CATHOLIC CON.

Lot No.	Name
253.	CATHOLIC CON.
280.	CATHOLIC CON.
39.	CLAREN, OSCAR VON
25.	COLL, JEAN JAQUES VON
272.	DRESEL, GUSTAVUS
178.	EIKEL, ANDREAS
60.	ELMENDORF, CARL
104.	ENGEL, CHRISTIAN
171.	ERNST, E.
58.	ERVENDBERG, LUDWIG
159.	FECHTE, GUSTAV VAN D
117.	FEICK, CASPER
52.	FEY, VALENTIN
69.	1ST PROTESTANT CON.
281.	1ST PROTESTANT CON.
53.	FISCHER, GOTTLIEB

Lot No.	Name
27.	FORTEMPS, CHRISTIAN?
276.	FRIEDRICH, AUGUST
277.	FRIEDRICH, AUGUST
?	FRIESENHAHN, ANTON
224.	GERHARD, WILHELM
102.	GOLDBECK. THEODOR
207.	GROOS, JOHANN JACOB
4.	HAMMERLE, FRANZ
30.	HANZ, CHRISTIAN
114.	HARTUNG, CHRISTIAN
113.	HARTUNG, JOHANN
51.	HARTWIG, LUDWIG
73.	HART, EDUARD VON
147.	HASSLER, JOHANN
109.	HEIDEMEYER, FRIEDRICH
19.	HEIM, JACOB
313.	HEINS, OTTO
36.	HEITKAMP, HEINRICH
154.	HELDBERG, GOTTLIEB
118.	HELLMUTH, MARTIN

21.	HENKEL, DONNERSMARK
52.	HENKEL, DONNERSMARK
233.	HERBER, CASPER
234.	HERBER, THEODOR
131.	HERBST, HEINRICH
193.	HERMANI, PETER
48.	HOF, CHRISTIAN
14.	HOFFMANN, GUSTAV
270.	HOFFMAN, JOSEPH
125.	HOLEKAMP, GEO, F
98.	HOLZAPFEL, JOHAN
111.	HORNE, PETER
145.	INHOFF, PETER
22.	IWONSKY, LEOPOLD VON
177.	JAHN, JOHANN JACOB
172.	KADERLI, JACOB
265.	KADERLI, JOHAN
210.	KAPPMEYER, JOHANN C
37.	KAYSER, CHRISTIAN
56.	KIRCHNER, GEORGE
181.	KLAPPENBACH, GEORGE
96.	KLEIN, JACOB
75.	KLEIN, JOSEPH
41.	KLEIN, STEPHAN
97.	KLEIN, VALENTIN
83.	KOCH, W.
105.	KRAFT, HEINRICH
123.	KRAKE, WILHEIM
94.	KREITZ, CONRAD
80.	KREITZ, JOHANN M
124.	KUEHN, WILHELM
264.	JAMES LEMON
285.	LINDHEIMER, FERD.
286.	LINDHEIMER, FERD.
267.	LOCKSTEDT, FRIEDRICH
81.	LOEFFLER, CHRISTIAN
79.	LUCK, CHRISTIAN
77.	LUCK, PHILIPP

93.	LUENZEL, CHRISTOPH
71.	LUX, HERBERT
122.	MARHEINECKE, FRANZ
63.	MATTERN, FRIEDRICH
119.	MEISNER, ANDREAS
43.	MERGELE, PETER
24.	MERTZ, JOHANN
50.	MOELLER, WILHELM
42.	MOESGEN, CHRISTOPH
266.	MORITZ, GERMAIN
34.	MUELLER, FRIEDRICH E.
29.	MUELLER, JACOB
297.	MUELLER, JOHN L.
15.	MUENZLER, FRIEDRICH
132.	NEGEDANK, LOUIS
165.	NETTE, DR. AUGUST
184.	NIX, HEINRICH LUDWIG
44.	PELZER, ADAM
3.	PETER, GERLACH
192.	PETRI, JOHANN
107.	POOK, LUDWIG
18.	REEH, GERLACH
202.	REICHE, HEINRICH F
?	REINARZ, WILHELM
84.	REINHARDT, JOHANN
126.	REINHARDT, JOHANN
112.	REININGER, HEINRICH
11.	REIS, PETER
134.	REIS
155.	REITZ, LORENZ
137.	REMER, DR. WILHELM
120.	REMMLER, GABRIEL
129.	RENNERT, JULIUS
160.	RENNERT, JULIUS
88.	REUTER, WILHELM
12.	RIECK, JOHANNES
64.	RIEDEL, ANTON
47.	RIEDEL, NICOLAUS
55.	ROEGE, HEINRICH

9.	ROSEER, HEINRICH
89.	RUSSER, ALOIS
74.	RUST CHRISTIAN
271.	SACHERER, GABRIEL
294.	SALZIGER, JACOB
182.	SALZIGER, JOHANN G.
295.	SANDER, MATHIAS
211.	SARTOR, ALEXANDER
213.	SARTOR, ALEXANDER
275.	SARTOR, ALEXANDER
214.	SARTOR, CARL
230.	SATTLER, WILHELM
82.	SAUERBORN, ANDREAS
235.	SCHAAF, HEINRICH
103.	SCHAEFER, CARL
35.	SCHAEFER, CHRISTIAN
116.	SCHAEFER, HEINRICH
99.	SCHAEFER, PHILIPP
227.	SCHELPER, HEINRICH
228.	SCHELPER, HEINRICH
106.	SCHERTZ, JOSEPH
110.	SCHERTZ, JOSEPH
200.	SCHERTZ, SABASTIAN
40.	SCHLICHTING, FRIEDRICH
70.	SCHMIDT, LEONARD
66.	SCHMIDT, EDWARD
268.	SCHMITZ, JACOB
61.	SCHMITZ, JACOB
170.	SCHNEIDER, JOHANN
229.	SCHOENE, HEINRICH
127.	SCHULMEYER, VALENT.
54.	SCHULZE, JOHANN H.
167.	SCHWAB, THOMAS
130.	SEELE, HERMANN
121.	SIEBERT, CARL HEINRICH
87.	SIEHN, E.
101.	SIMON, FERDINAND
168.	SIMON, SYLVESTER
186.	SPANGENBERG, CHRIST.

96.	SPIESS, HERMANN
53.	STAATS, JOHANN
45.	STARTZ, JOHANN
85.	STERTZING, THEODOR
162.	STERTZING, THEODOR
90.	STOCK, CARL
5.	STOCK, PETER
151.	SYRING, CHRISTIAN
6.	TAUSCH, FRIEDRICH
7.	THIEL, CHRISTIAN
136.	THIELEPAPE, JUSTUS G.
1.	THOMAE, CARL W
281.	TOLLE, CHRISTOPH
?	TOLLE, GEORGE F.
137.	ULLRICH, GEORGE
150.	UNTERMOEHLEN, FRIE.
273.	VOELCKER, HEINRICH
274.	VOELCKER, HEINRICH
59.	**VOELCKER, JULIUS**
65.	VOGEL, LUDWIG
183.	VOGT, ADAM
46.	WEDEMEYER, ADOLPH V.
108.	WEIL, PHILIPP
174.	WEINERT, AUGUST
173.	WEINERT, REINHARD
2.	WENGEROTH, JOHANN
157.	WENZEL, GEORGE
158.	WENZEL, IGNATZ
8.	WERSTERFER, JOSEPH
164.	WETZEL, WILHELM
23.	WEYEL, ADOLPH
78.	WEYEL, JACOB
231.	WIEDENFELD, THEODOR
232.	WIEDENFELD, WILHELM
135.	WILLKE, LUDWIG
128.	WILLKE, HERMAN
57.	WINKLER, PETER
92.	WREDE, JOACHIM F.A.

The museum was fascinating and I could have spent all day there, but it was time to get to work. After pulling myself away from the museum, I walked over to the library area and paid the research fee required. As soon as I walked through the glass door entrance, a strange feeling came over me. The best way to explain it is that the room felt overcrowded with people, even though only four staff members were present. I asked one of the research department volunteers if they might have vertical files on New Braunfels's unsolved deaths, murders, crimes and so on. She kind of looked at me funny and was rather hesitant at first, which I thought odd. It is a museum and library—was I the first to ever make such a request? Reluctantly, she began to guide me to an area with numerous old books on the back wall. As I followed the staff member toward the books, I noticed a tall metal filing cabinet that read, "Murders, Crimes and Prisoners." With the file label showing exactly what I had asked for, I thought it strange that she would lead me away from this cabinet. Not wanting to be rude, I continued following the woman to the shelves of books and then thanked her. As soon as she headed back to her work station, I turned tail and practically ran over to the cabinet—it was like the cabinet was a huge magnet and I was wearing a suit of metal armor. I was so unbelievably drawn to the thing I nearly tripped over a chair to reach it.

I opened the cabinet drawer with the unusual labeling and noticed how overfilled it was. My first thought was, "Dang, I had no idea New Braunfels had so many unlawful deaths." I grabbed a handful of files to begin thumbing through when the strangest thing happened. One of the files almost jumped out of my hands and onto the floor. I was somewhat embarrassed since the woman had guided me to the old books and now I was clumsily flinging documents to the floor. I smiled and quickly scooped up the tossed papers. As I was placing the papers back into the files, I could see the corner of a black-and-white picture. I pulled the picture out, and it was an old photo of the sweetest-looking young girl. The child had long dark hair that had been neatly curled with a hot iron and was wearing a thin headband. She looked so angelic in her polished "Sunday best" ensemble. Her dress looked of fine shiny silk and stiff white lace. The outfit was made somewhat oversized, allowing for growth

throughout her years. Although her face showed no emotion, she looked so sweet and innocent.

This may be difficult to believe, but as I stared into this child's kind eyes, I felt as though we had met before. It was a strange feeling, to say the least. Looking back now, that was definitely a key moment on this journey. I'm not certain, but this young spirit might have used me as an instrument to unearth her hidden secrets, or perhaps I simply had reached a place in my life that was to be my destiny. I guess I really won't know the truth until my time has passed, but something profound definitely happened at that precise moment. My gut told me that I was on to something big—I just didn't have a clue what.

Statue of Prince-Solms Carl Braunfels. *Photograph by Megan Foster, Seguin, Texas, meganfosterphotography.com.*

After picking up all the papers that had fallen out, I took the ruffled file over to an empty research desk. When I opened the folder, I saw a few old newspaper articles, but they were all written in German. I may have German ancestry in my blood, but I had no clue what the words said. Then I noticed that someone had translated the entire newspaper article and typed it out. As soon as I began reading the words, I knew in an instant that this was the little Comal town ghost the woman had spoken of. It felt as though I was being time-warped into the past and the reporter was speaking directly to me. This is what it said:

It all began July 1874 around 1:00 AM when a 15 year old boy, Emil Voelcker heard a loud noise coming from his sister's room that awoke him during a sound sleep. When he entered the room to check on her, he saw a man standing on the other side of her room. The man covered his face and rapidly exited the room in such a rush he pushed Emil to the floor. When Emil got back on his feet he could see his twelve year-old sister, Emma, lying on a mattress on the floor, a pool of blood under her head. She had received a horrible blow that delivered a gaping wound to her forehead. He then turned to look at the bed on the other side of the room and saw their friend, Helena Rhodius Faust [wife of druggist William Faust from Seguin]. *She was visiting the family at their home on the corner of Castell*

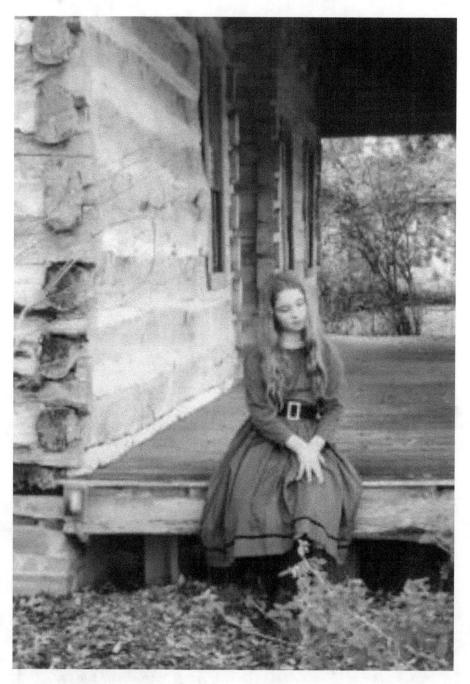

Reenactor (actress Abigail "Abby" Martin) playing the part of Emma Voelcker, the young girl murdered in her own home. *Photograph by Catherine Martin.*

Street at the time and had also received a hard blow to the head. The frightened young boy screamed for his parents, Julius [Karl] Voelcker [a well-known New Braunfels druggist] and Louisa Karbach Voelcker, who quickly arrived. To their horror, the cries of the mother saying "my child has been killed, my child has been killed" could be heard by neighbors from blocks away. It was loud enough to wake their neighbor, who happened to be Sheriff Ernest. He heard the dreadful call in his own home, quickly dressed and ran to the Voelcker house. When the Sheriff entered their home located directly behind the family's drug store, he was quoted as saying it left him with a mental image he would never forget. A doctor was called and quickly arrived but it was too late for the young girl, Emma. Within a few hours she would pass away from the injuries. Although Helena Faust survived, she was to be completely blind forever. The news of the attack spread fast and a posse of 20 men was dispersed in all directions to alert surrounding communities to be watchful of any suspicious persons. They interrogated all strangers and asked the citizens to please maintain order to protect the innocent in the hysteria.

Still without any suspects, Emma was buried July 25 1874, in the Comal Cemetery. Her funeral procession was the largest during that time. The Pastor Schuchard who performed the funeral sermon read the lyrics from the German song, "When the Swallows Fly Homeward" to provide comfort for the breaking hearts of everyone present. Once everyone went home, the mystery of the incident began to intensify as people spread absurd rumors and accusations that lead to several unwarranted arrests and near lynchings. Then, one rather important claim was made that caused great suspicion: William Faust, husband of the victim, Helena was missing and could not be found anywhere. He was now the prime suspect. Helena was moved to the home of her mother, Johanna Rhodius for safe keeping. After weeks of searching, William was found in Cibolo, immediately arrested and accused of Emma's murder. Thus began the long investigation and trial of the perpetrator who was unbelievably the surviving victim's own husband.

The presiding Judge of the 22nd District was John P White, the state was represented by attorney and eventually 18th Governor of Texas John Ireland and the accused was represented by attorneys Rust, Goodrich and Douglass of Seguin. Once the lengthy trial was initiated it would become the topic of conversation on everyone's lips for miles around. Now that a suspect had been named, the witnesses started to come forward. As each eyewitness approached with their accounts of what they had observed

William (Wilhem) Faust doing and where he had been on the night of the murder, it was growing more and more agonizingly obvious that the accused was guilty. Though during everyone's testimony William Faust remained completely emotionless, masterly controlling any reactions, which would be impossible for any innocent person. An attorney was quoted as saying "William Faust's behavior during the trial demonstrated that he both had a heart of steel and knows how to discipline himself in very trying situations, or he is the biggest criminal with a soul as black as the darkest night."

It was told by Faust's wife that it was her husband who had suggested she sleep at the Voelcker's house that night. Despite the fact she refused to believe he had committed the crime and continued to stand by his side, she was still able to give her version. It seems that Helena Faust had a dreadful phobia of sleeping alone through the night. Since her husband was to work in Seguin that night, William suggested she sleep at the Voelcker's in New Braunfels for security. Once she arrived at the Voelcker's home, it was decided she would sleep in the room of the young, Emma Voelcker. Emma slept on a floor mattress while Helena slept in Emma's bed. It was to be this decision that would cause Emma's demise. A witness saw William Faust racing on horse in full gallop back from New Braunfels to Seguin during the early morning hours on the night of the murder. He was headed to Seguin's infamous Magnolia Hotel where he was staying in room #3 for the night. William was also riding the horse of Magnolia Hotel owner, Rollin Johnston.

Yet this was never mentioned to anyone because the thought that a woman's husband could do such a thing was incomprehensible. Furthermore, it was discovered that an axe was used to kill the Voelcker girl and blind Mrs. Faust. The murder weapon was found tossed in the Guadalupe River. It was found with blood and nerve fibers still remaining, and determined to belong to William Faust. As the incriminating evidence accumulated so did the anger. The reality that a friend of the Voelcker family and husband to the victim could actually carry out such a hideous act was extremely painful for everyone to accept. William Faust had to be moved continuously to avoid being lynched. Finally, on October 22 1875 after close to a year of agonizing delay, a verdict was reached and the word "guilty" handed down from the jury. His sentence was life in prison.

Faust's reaction sickened everyone in the courtroom. All he did was slowly look at each twelve men on the jury, glance at the judge and his lawyer, then, without a twitch of a muscle leaned back to light up his final cigar. This cold blooded response brought chills to all within sight.

For months Faust had to be moved from one jail to another to avoid irate lynch mobs. Unbelievably, while Faust had finally been moved to a San Antonio jail he decided to confess to the murder, giving the full details. He admitted that on the night of the murder he rode the stolen horse from Seguin to New Braunfels, arriving around 1:00am. When he entered the Voelcker's home it was his intention to only kill his wife but the young girl, Emma awoke so he was forced to kill her to save being recognized. Emil Voelcker walked in before he could finish murdering his wife. After the attack he jumped on his waiting horse, threw the axe in the Guadalupe River, burned his bloody clothes and changed into clean ones. Then he rode the horse hard back to Seguin to the Magnolia Hotel as quick as possible arriving around 5:00am. He stated the only mistake he had made was not pretending to help in the efforts to search for a murderer. He was quoted as saying "had I done that, all suspicion toward me would have been removed." Astonishingly, Faust went on to admit this was not his only murder. He had also killed Dr. Rhein in Seguin a few years back for money he had owed him. When asked why he would want to kill his own wife? "My plans were to kill Helena (my wife), wait a while to collect her $9000 inheritance she was to receive from her previous deceased husband in Germany, then marry her sister. Had the little girl not awakened, I would have gotten away with it."

As fate would have it, several days later a number of men attempted to break into the jail where Faust was held but were stopped. The Sheriff moved the prisoner to the courthouse and placed him under heavy guard; nevertheless, on July 28 1876 between 3:00–4:00am Faust was shot to death by unknown hands through a window. The culprit was never found.

As I read the last sentence of the article, the room's lights seemed to grow dim and I felt rather lightheaded. I started getting that unusual feeling you get when a migraine is about to set in. For a moment, I thought that I was getting ready to pass out. I placed my head in my hands and closed my eyes to rest a bit, and then something strange came over me. Suddenly, I felt the walls close in on me as though I was pulled down to the bottom of a dark well. The sounds from the volunteers working in the room grew completely silent, as if I was abruptly all alone. When I slowly began to open my eyes, I could see a faint light and the silhouette of a man in front of me. The man was reaching toward me with open arms as if he wanted to pull me out. As I started to reach out my hand toward him, I suddenly heard, "Miss? Miss? Are you okay?" I gently gasped and then rapidly opened my eyes. The question had come from one of the research volunteers standing next to me.

I quickly checked all around me, making sure this experience wasn't real, and then told her I was fine. I looked over toward the counter, where another research volunteer was working, and she was smiling at me. I smiled back at her and then shook my head slightly to clear my mind and blinked my eyes a few times. That was one eerie moment, to say the least. Throughout my life, I've had unusual experiences before, but none like this. It really did catch me off guard.

I regained my composure and continued looking through the rest of the papers in the folder. So many things about this brief translated article sent chills up my spine. It caused a lot of questions for me too. This tragic event would have been an enormous story back in 1874. Even by today's standards, this crime would be huge news. The first multiple killer in New Braunfels, heck maybe in Texas, and my grandmother never shared this with me. She must have known about it. The German community of New Braunfels was a very tightknit group of people, and my Zuercher ancestors' house was located just a few blocks down from the center of town. My grandmother had to have known about this crime. Why didn't she tell me this story? Something just didn't feel right about this new discovery. A lot of questions started running through my mind. One of the things that captured my attention the most was that John Ireland was the prosecutor.

Oddly enough, throughout my childhood years, I had always been a huge admirer of John Ireland. He had been a lawyer who went on to be the eighteenth governor of Texas. I looked at him as something like a historic mentor.

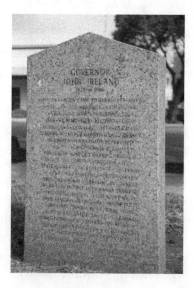

Something else I thought peculiar in the translated article was how it stated that the murderer stayed at the Magnolia Hotel in Seguin the night of the crime. Funny, I lived in Seguin for nearly five years when I returned to Texas. How could I not have known of a place called the Magnolia Hotel? The article even stated that the hotel was "infamous." I'm a retired historian who craves history. I checked out every historic location during my time in Seguin and never heard of this hotel. Had it been torn down or renamed something else?

Governor Ireland's memorial. *Photograph by Megan Foster, Seguin, Texas, meganfosterphotography.com.*

With the library now about to close, I asked the staff member if I could have copies of the file—she agreed, reluctantly. Once I had my stack of papers with this interesting new story, I headed back home to Austin. During my entire drive back, I kept thinking about the article. There was one specific line that really stood out to me: "Once the lengthy trial was initiated it would become the topic of conversation on everyone's lips for miles around." This murder would have deeply shaken the citizens of New Braunfels and Seguin. It wasn't until a year or so later that the murderer was finally convicted too. Newspapers in the larger surrounding cities like San Antonio, Galveston and Austin would definitely have picked up this horrendous story. Why didn't my grandmother tell me this story?

Once I got home, I shared my findings with Jim. He is a huge skeptic, so he wasn't that impressed about Emma possibly being the traveling ghost, but he was captivated with the actual story. Even he agreed that this brutal crime back then would have been the topic of conversation for years. We discussed the enormity of this story for hours. Jim felt that I was definitely on the right track of Emma being the traveling spirit and that it would make a fascinating story. On the other hand, he wasn't too happy when I told him about my near blacking out experience at the museum. He made me promise that if it happened again, I wouldn't go back to the museum. That was an easy promise to make, as that experience really did startle me.

By now, it was getting late, and we were ready to call it a day. I had such a hard time falling asleep that night. Thoughts of this poor little girl kept whirling around in my mind. I knew that I needed to let it go, but it was difficult. There was something about this story that just didn't sit well. I couldn't quite put my finger on it, but it didn't feel right to me. I finally fell asleep, but way after midnight. Trust me when I say this is very late for me. I personally am no night owl. I usually hit the sheets before 10:00 p.m. So believe me when I say I was pretty exhausted by now. However, at about 2:00 a.m., I had a terrible nightmare.

All my life, I have had powerful nighttime dreams, but nightmares were not common for me. This dreadful dream had me practically jumping out of my bed from fear. Once I woke up from it, I was so upset that poor Jim had to calm me down. He asked what the nightmarish dream had been about. I told him that all I could remember was darkness and then loud screaming. I kept trying to run toward the screams, but my feet wouldn't move. It was like my legs were glued to the floor. We both agreed that it was from reading and thinking way too much about Emma's murder. Going to bed so late didn't help either. He said I needed to clear my mind

and try to go back to sleep. I tossed and turned a little more, but eventually I fell asleep from pure mental exhaustion.

The next morning, I dragged myself to the kitchen to make some coffee. Once I poured my first cup, I sat down at the kitchen table and grabbed the file of copies I had made at the museum. I took out the translated article and began to read over it another time. So many questions ran through my head about this case. Then I pulled out the picture of Emma to simply study her face more. Although she appeared to be looking at the camera with such seriousness, it felt like she was looking right at me. Her eyes seemed so thoughtful and gentle. I wondered how old she had been when she took this picture. Her life had been ended at age twelve, and I pondered if this picture was taken just before her death or whether she was a bit younger then. The dress she was wearing looked so elegant, and the curls on her head were perfectly arranged around her shoulder. This little girl's parents must have been so proud of their only daughter. I couldn't help thinking how painful it must have been for the parents to see their precious child murdered—and while in their very own home. What a horrific sight that must have been for them. I noticed that I was becoming way too emotionally involved in this child's death. I needed to shake this off and fast to be able to focus on my writing. I decided to put her picture at the back of the file so I couldn't see it. I was hoping that the old saying "out of sight out of mind" would be proven true.

I started laying out the story of this Comal Town Traveling Ghost. It was important to give my evidence on why I felt this little spirit was Emma Voelcker. I began to think about how her home had been located on the corner of Castell Street and that she was buried at the Comal Cemetery. If one were to walk from her house to the cemetery, this is exactly the path on which the traveling spirit had been seen. It made clear sense to me that this dear child spirit was only heading back home, as she had done many times before. It was plausible that she may continue to wander the streets of New Braunfels because of how she passed away. One minute she was sound asleep, safe in her own home with her close friend Helena Rhodius Faust near her, and then before sunrise, she would be dead. I felt comfortable stating that Emma was the Traveling Ghost, without a doubt in my mind. With that said, I started writing her story.

As I typed each word, I kept thinking about this unfortunate family. Emma's father, Julius Voelcker, must have been one of the original founding families of New Braunfels, just as my ancestors were. The article stated that Julius was a druggist and that his shop was directly in front of their home.

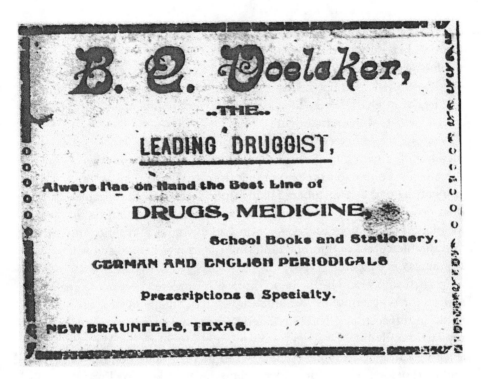

Voelcker Drugstore advertisement. *From the* San Antonio Daily Express.

I'm certain my ancestors would have frequented his shop. Julius most likely filled their prescriptions as well. In small towns, everyone knows everyone's business, especially in tight German communities. The odds that the Voelcker family knew the Zuerchers were pretty good. Then I noticed that I was thinking more about his family's life than writing. This short story was taking way too long for me to complete. I thought maybe if I began thinking about what pictures I was going to use it might help clear my head. It seemed like a good plan, so I stepped away from the computer keyboard and began searching for pictures to include in this story.

Given that Emma's father was a well-known druggist, maybe something related to his store would be fitting to include. I thought that an old advertisement from the family's drugstore would be nice.

I knew that this had to exist, as advertising in local newspapers was the only way to get the word out back then. This would be an easy enough task to accomplish by simply checking out the old newspaper archives at the public library. Maybe while I was there, I could possibly locate where the Voelcker Drugstore had been located in New Braunfels too. Then I wondered what

else would be useful to set the scene of this event. I thought that a picture of Emma's headstone would be appropriate as well. Visual confirmation that her life had been cut short might offer legitimacy to the account. All I would need to do is locate her headstone in the cemetery and take a few quick pictures of it. I had been to the Comal Cemetery many times, as some of my own ancestors were buried there.

Visiting this cemetery was always an enjoyable outing. It is located on top of a high hill with lots of shade trees. The Comal River is down below, so there is a constant soft breeze coming from that direction. In the summer, you can hear the river tubers talking and giggling in the distance as they float downstream. The cemetery, with its serene feel, would be the perfect location to clear my head. So, I got dressed for the day, grabbed my camera and the file copies and jumped into my car to make my way back to New Braunfels once again.

My first stop would be the public library. I wandered over to the genealogy section for books on New Braunfels history. I actually owned many of the books in this section. I had purchased them many years ago for researching my own family line. I had never given any thought to the Voelcker family since I didn't have a direct connection to them. I pulled out a few books I had read before, but this time I looked up the Voelckers. As I was thumbing through one of them, I noticed that both the Voelckers and the Zuerchers were listed as arriving in Texas around the same time. I then went over to my binder with the copy of the list of original founders the museum staff member had given me. Sure enough, there he was. Julius Voelcker received lot 59, and my Nicolaus Zuercher got lot 142.

There was no way on earth these families didn't know each other. With both families being part of the founding families of New Braunfels, I was becoming even more intrigued with this story. Every book I opened about the history of New Braunfels, there was my family and Emma's family mentioned. Julius Voelcker, his drugstore and his sons were spoken of at great length too. Strangely enough, there was little mention of his daughter's murder other than she died at a young age. Hmm, this seemed quite odd to me. There was tons of info on Julius, his successful drugstore and how his sons went on to follow in his footsteps as druggists, but no mention of Texas's biggest murder case in the mid-1870s. I continued exploring these local history books and soon came across pictures of the Voelcker Drugstore. I was blown away once I read the pictures' caption. It stated that the drugstore had been located on the busiest corner in the downtown area. When I looked at the picture closely, I recognized the building.

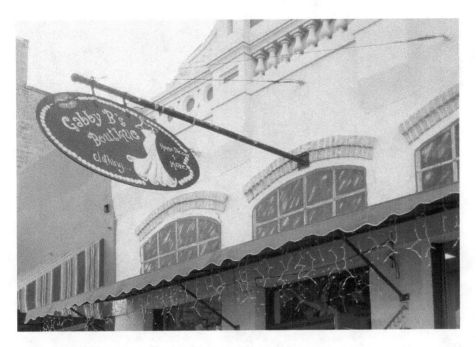

Gabby B's Boutique. *Photograph by author.*

For years, my daughter, Jennifer, owned a clothing boutique in the downtown area called Gabby B's. Her building was one of the locations I was including in my *Haunted New Braunfels* book, but now it was under another name.

The old Voelcker Drugstore was right down the street from her shop. I had walked past this building countless times and never had a clue of its importance. The fact that the structure was still standing nearly took my breath away. On top of that, there was a popular business located inside the building, which meant that it was open to the public. I couldn't wait to stop by this shop to see if maybe there was something related to the Voelcker Drugstore still on hand. I put back all the library's history books, gathered my stuff and drove over to the old Voelcker pharmacy building.

Sure enough, there was the building. It had been modernized with stucco and paint, but if you look at the picture of the original building next to its current state, you can definitely see that it was the same building. I also had a copy of an old picture showing the interior of the drugstore in the 1880s. With great anticipation, I walked inside to see if it had changed much. Although the entire building was laden with beautiful new items for sale, it hadn't changed that much as far as the design.

SAN ANTONIO STREET, SOUTH FROM PLAZA, NEW BRAUNFELS, TEXAS.

Voelcker's drugstore, corner right building. *Author's collection.*

The second floor was still visible with stairs leading up. There was the original cash register right next to the checkout counter. After I walked around a bit, I went up to the counter, where an employee was doing some bookkeeping. She greeted me with a nice smile and asked if I needed any help. I must have been beaming with excitement. I was so delighted to talk to her about the building I could hardly contain my enthusiasm. All I wanted was to see if she had any additional information on the building beyond what I already knew. I told her I was a writer doing a book on New Braunfels history and some of the ghost stories from around the area. I mentioned that I was writing about the Voelcker family who once owned the building as a drugstore. Then before I could say another word, the nice smile on the employee's face suddenly disappeared, and her eyes got rather large.

She told me she didn't want anything to do with ghosts. I was kind of caught off guard by her abruptness. I wasn't expecting such a quick, harsh reaction. All I wanted to know was if she might have any photos or old artifacts from the drugstore era that I could take pictures of. Although she was not unpleasant toward me in any way, she just seemed rather troubled by the word *ghosts*. This didn't upset me at all. I am well aware of how some people are easily frightened by just the possibility of ghosts existing. What did concern me was how terrified she seemed from the mere mention of

ghosts. Her reaction most definitely piqued my curiosity. I quickly assured her that I respected her wishes but asked if she would mind sharing why she was so alarmed. Then she said, "I had a few bad experiences, and I just don't want to go there ever again." Not wanting to be rude and pry, I told her I totally understood. I expressed how beautiful her store was and noted that I would come back to do some shopping when I had more time. I could see her whole demeanor change, and she became more relaxed. She gave me a smile, told me thank you and then turned her attention back to her paperwork.

As I headed toward the exit door, I suddenly felt something strange near me. I knew that there was a presence, but I didn't want to frighten the employee. So, I just whispered, "I know you're here." Right as I said that, my left arm was pulled backward, as if someone did not want me to leave. Then I felt a massive wave of an electric tingling sensation throughout my entire body. There was definitely high energy in this building, and oh how I wanted to stay longer. I felt bad having to walk away from the spirit that was trying to make contact, but I knew that my presence was making this employee extremely uncomfortable. I felt it was best to keep walking, even though I desperately wanted to stay.

As I walked toward my car, I kept looking back toward the store windows, hoping to maybe see the presence. Unfortunately, all I saw was the nervous employee making sure I left. I then got in my car, started the motor and headed for the cemetery.

As I pulled my car up to the cemetery, I noticed some things about this graveyard that were out of the ordinary. How fitting that the street it was situated on was called Peace Avenue. Since this trip was to do research for a book instead of simply enjoying a visit, I paid far more attention to detail. I observed the intricate iron archway that stood above the back entrance. It read, "Comal Cemetery," with the years 1870 and 1910 on both sides of it.

The grounds are always so well kept and groomed. It has a paved path for cars to enter, sidewalks for visitors and fresh flowers on many of the grave sites. With it being so immaculate, one can tell that the community considers this cemetery to be a valuable historic part of its heritage. As a descendent of some of the folks buried here, I have always been enormously grateful for the continued upkeep of the cemetery. Given that the graveyard is so well maintained and attractive, it draws in tourists from all over the world. This day, there were only a handful of people walking around inspecting the old dates and German names of the headstones. I parked my car and began searching for Emma's headstone.

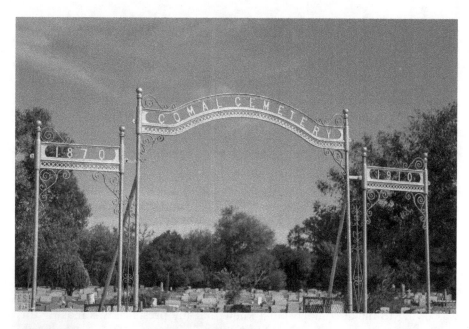

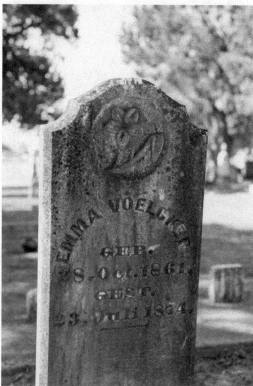

Above: Comal Cemetery entrance. *Photograph by Megan Foster, Seguin, Texas, meganfosterphotography.com.*

Left: Emma's headstone. *Photograph by Megan Foster, Seguin, Texas, meganfosterphotography.com.*

I wasn't exactly sure where Emma's grave site was located, so I began strolling up and down the cemetery rows of memorials. The grave sites in the front seemed older than the ones in the back, so I started in that area. A lot of the names on the tombstones were familiar to me. They were listed on the founding family's list and in many of the history books. I saw the words *Mutter* and *Vater*, which I recognized as being "Mother" and "Father" in German. Because of how often my mom and grandma spoke of our German ancestors, this vast surrounding of German names felt almost like a family reunion to me. Although I was born and raised in San Antonio, with all my mother's stories being about New Braunfels it always felt like home to me. The feeling of belonging was rather nice. I continued strolling up and down the rows of grave sites as I read the names off in my head. Then I saw the name VOELCKER on a headstone, and I rushed over to it. There it was: Emma's grave site. I was beside myself with sheer delight. How bittersweet it was to actually locate this dear young girl's resting spot.

Here was my little traveling spirit, whose short life had consumed so much of my thoughts in the previous few weeks, and now I was standing in front of her grave site. I was so pleased to have been able to locate it so quickly. I looked around, wishing there was someone nearby I could share my discovery with. This cemetery is not small, so I was thrilled to have found it so fast. Once I settled down from my excitement, I knelt down to pay my respects.

Then I thought of how uncaring I was to not have brought flowers for her. It felt like I had been invited to a friend's home for a party but had forgotten to bring a hostess gift. Then I remembered when I attended a Jewish funeral once, they had a tradition of placing rocks on top of headstones to symbolize that you will never forget them. So, I searched around for a pretty rock, dusted it off and placed it on her headstone. I made a conscious decision that when and if I ever returned, I would bring a bouquet of white daisies (which are my favorite) for her to enjoy, but a shiny rock for now would have to do.

Since no one was around to watch, I decided I was going to have a nice long (though one-sided) conversation with her. I brushed away leaves and sticks for a somewhat smooth spot on the ground to sit. I plopped myself down and admired how delightful her grave site was, situated with so much shade from the tall trees. I looked at her headstone and how it was written in German. Gosh, she was born on October 28, 1861, a few months after the Civil War had just begun. I don't pretend to know anything about what New Braunfels endured during the Civil War. But I am certain that this must have

been a difficult time for this family, especially being parents of three young sons and a brand-new baby girl.

Emma had been killed on July 23, 1874, making her only twelve years old. I was saddened at the thought of her having died so young. At that age, your life is basically just beginning. Sadness was overcoming me, so I forced myself to think of something else. I started speaking to Emma as if she were sitting right next to me while hoping no one was watching.

I told her that I knew her story and that I was going to share it with the world. I told her soon everyone would know how she died and who had committed the crime. She would now finally be able to be at peace. There would be no need to wander the streets of New Braunfels for someone to tell her tragic tale. It was okay now to move to the light and be with the rest of her family. There was such a pleasant feeling of calm around me. Not sure if it was because I had collected everything I needed for the story now or because Emma might be listening to me. Whatever the case may be, I was in a happy state of mind. I glanced around the cemetery, thinking how serene the area was. Emma's resting spot had been well chosen; it gave me a strong feeling of contentment.

Hoping that maybe I had helped this little girl find closure, I thought it was time to walk away. Then I remembered I needed to get that picture of her headstone before I left. I started to stand up and then reached for my camera. As I stood up, a strong gust of wind came up from the riverbank and nearly blew me off my feet. I had to quickly cover my eyes from all the dust flying. This was totally weird! It was like one of those Texas dust devils that occur in the summer heat, swirling around, picking up specks of dust and leaves. The sky was perfectly clear with no clouds in sight, so where this wind came from I had no clue. Even the cemetery caretakers were looking around in awe at this strong, sudden breeze. I brushed the dusty debris from my clothes, smoothed out my messy hair and then went back to taking a picture of Emma's headstone. After clicking several shots, I looked at her grave site intently one more time. Something told me this wouldn't be my one and only visit. I guess you could call it intuition, but whatever it was, I knew I'd be back someday. I headed back home to Austin for a hot bath since I was head to toe dusty from the dirty breeze and hoped I'd get a well-deserved good night's sleep.

THE DREAMS BEGIN

That night, I was able to fall asleep relatively easily, with no horrible nightmares waking me up, but I did experience a very vivid dream. My mother taught me to always write down my dreams if I felt them to be of importance. These types of dreams have the capability of leading to a premonition of things to come, like a collection of clues that would eventually lead to a treasure. The treasure is finally discovering what the premonition meant all along. As soon as I woke up, I jotted down the dream. The dream I had was an addition to previous dreams that I had been experiencing for years. They would come in short clips until the dream was almost like a short story. I used to share this vision with a close friend as it progressed because she was always in the dream too.

The dream always opened with me dressed in 1880s clothing standing in a bedroom located on the second floor of a two-story building. I'd see an open window across the room and then would walk over to it and pull back the delicate, thin, white lace curtains hanging on them. I'd look down to the street below and see horse-drawn carriages going by and people walking on the wooden sidewalks across the street. I could even feel the breeze as it came through the open window. There would be ladies wearing elaborate outfits with fancy hats on top of their heads slowly strolling to their destination. One lady would always have a white parasol opened and continuously twirled it in circles over her head as she walked down the sidewalk. The lady was so beautiful. She'd look up and wave hello to me with a huge smile on her face. In the dream, I knew that she and I were

friends, and I enjoyed seeing her. I'd smile and wave back at her, and then slowly I'd let go of the curtain to gently fall.

Then I'd turn around to look and head to a doorway leading to a stairway. As I looked down the stairs, there would always be a tall, heavyset man waiting for me to come down. He'd have on a suit with a gold watch on a chain hanging out of his pocket. He'd pull out the pocket watch and check the time. Then he would stretch out his arm, beckoning for me to come down. The emotional feeling I had for him was that of a close friend or maybe a brother. As I came down the stairs, he'd reach for my hand. When I got to the bottom of the stairs, he would gently place his hand in mine. When he lifted his head toward me, I couldn't see his face. It was as though a shadow was covering his face, and I couldn't distinguish who he was. He'd guide me into the elegant foyer, where the huge door leading out would open. The minute I got to the doorway, he'd say to me, "It's time. He's waiting for you. Go on now." As soon as I'd take the first step beyond the doorway to walk outside, I'd see children laughing and playing with old-timey toys like croquet, a thin wheel pushed along by a stick and horseshoe tossing. Then I would hear my friend's voice calling my name. I'd turn to look at her, and she'd say, "Erin! He's here, Erin. Look!" Then, as soon as I'd turn to see who it was, I'd wake up. It used to frustrate me like crazy because I so badly wanted to know who this man was.

Well, I had the dream again that night, and it started off just the same as always. This time, it was a little different. Although I still didn't get to see the person my friend said was waiting for me, I did turn around to see the front of the building I had exited from. As I looked up, it was a two-story white building with the words "Magnolia Hotel" on it. When I woke up, I knew this was profound.

First off, I had been having this dream over the course of nearly ten years. This was the first time it had gone beyond my friend's calls to me. Another thing that was rather thought-provoking was the name of building. I wondered if it was simply because Emma's story had been in my thoughts since the day I first read about her—or did this mean something else? In any case, I jotted down the addition to my dream and went for my morning coffee to get my mental motor running.

I told Jim about the dream I had the night before and about seeing the name Magnolia Hotel on the building. He agreed that with all the attention I had been giving Emma's murder case, my brain was simply experiencing detective overload. I giggled and told him he was probably right. Nevertheless, I thought it would be cool if I could locate this mysterious hotel and get a

picture of it for the book. This find would be an awesome addition to the story. Given that my next book was *Haunted Seguin*, it seemed like a good way to connect the two cities and the two books. Jim thought it was a good idea, too, but only if I could find it rather quickly. The deadline was creeping closer by the day, so I needed to hurry up.

The next day, I went over to my older sister's house in Seguin for a visit. I was hoping she might have heard of this elusive Magnolia Hotel mentioned in the translated article. She had been living in Seguin since 1998 and was active in local social activities. If anyone would have known about this building, it would be her. I rang the doorbell, and when she opened her door, she gave me one of her wonderful "hello" hugs. We sat for a good while, making idle chit chat as usual. Then she grabbed an old newspaper clipping that was on her dining room table and said, "While I'm thinking about this, here is an old article I found at a garage sale. I know how you like old historic buildings so I thought it might interest you." I reached out to take the article, and then my mouth dropped all the way to the floor. I looked up at my sister with my eyes practically popping out of their sockets. She said, "Are you okay?" The newspaper clipping was about the Magnolia Hotel! I asked her, "How on earth did you know I was looking for this old building?" She looked at me somewhat confused and said, "I didn't. I just saw it, and it seemed like something you'd enjoy reading. Why are you looking for it?" I told her she needed to sit back down—that I had one doozy of a story to tell her. After I shared Emma's story, she was mesmerized and said, "Just like Momma used to say—there's no such thing as coincidences." I told her I agreed and then gave her a hug goodbye.

As soon as I got home, I ran to my study and turned on my computer. The article on the Magnolia Hotel was proof that the building may still exist, so I wanted to see if I could perhaps locate where. A current picture of this building would definitely enhance Emma's story, so I was determined to find it. I was also becoming overwhelmingly curious about this mysterious building, especially after the surprise of the newspaper clipping. As I sat at my computer, I thought the best place to start would be a simple Google search. So, I typed in "Magnolia Hotel Seguin Texas" to see what was out there on this elusive building. To my surprise, there wasn't any information except a YouTube video. The title of the video was "Seguin, Texas Preservation Month Magnolia Hotel." I quickly clicked on the video and began watching it.

The first picture on the screen was an old black-and-white photo with text that read, "The Original Magnolia Hotel." Then a woman is seen holding

Rich history lives at Magnolia Hotel

Editor's Note: This is the second in a series of stories this week highlighting stops on the Holiday Heritage Tour.

The Magnolia Hotel located at 203 S. Crockett played an integral part in the early days of Seguin. It began as a two-room log house built in the early 1840s by James Campbell sold to Joseph F. Johnson.

He made some additions and turned it into a hotel. In 1846 he sold it to Michael Erskine and Jeremiah S. Calvert. Texas Ranger Capt. John Coffee Hays married Susan Calvert, daughter of Jeremiah Calvert, at the Magnolia Hotel in 1847.

The Magnolia Hotel was located on the Stagecoach Road, the first road surveyed in Guadalupe County. Joe Comingore, local historian, notes that the Magnolia Hotel was an important stop for the stagecoach, with lines operating from Houston and Austin. Another source notes that at the northwest corner of the hotel there is an old stone block from which a bell was rung to signal the town of the approach of the stagecoach.

The Crockett Street portion of the hotel is a limecrete structure. The two-story, frame, Greek Revival part facing East Donegan was added to the complex by 1902 and is visible on a Sanborn map from that year. A massive renovation was undertaken in 1936. Very little was

Holiday Heritage Tour

The Magnolia Hotel, 203 S. Crockett, is among the stops featured on an upcoming Holiday Heritage Tour on Dec. 1 from 1-5 p.m. Tickets are $10 in advance or $12 during the tour.

altered since that time.

The original windows, doors, entrances and pilasters and cornice board remain. The information submitted to the National Register of Historic Places states that the frame structure is the oldest building of that material surviving in the Downtown Historic District of Seguin and perhaps in the city.

The Magnolia Hotel is currently owned by family members who inherited the site. The family hopes that the property will be purchased by an individual or an organization that will preserve and restore this important historic resource in the community.

Come visit the site on Saturday, Dec. 1 from 1 to 5 and here the history of this place. Get a glimpse inside and imagine the prospects. Tickets are available for the tour at Girt & Gourmet, Cascades, Keepers and the Seguin Chamber office for $10 pre-sale. Day of tour tickets are $12 and available at all tour sites.

Courtesy photo

Author's sister's newspaper clipping. *From the* Seguin Gazette.

a large poster of a dilapidated, worn-out, two-story building with numerous cars parked right up against it. The cars were parked so close to the building it looked like they were practically touching the exterior walls. She begins by saying, "We are here at the site of the Magnolia Hotel, part of the National Historic District." My thought was, "Geez, it is part of the National Historic District?" Then the woman continued, saying, "We are here to celebrate one of Texas' most endangered sites." Talk about a roller coaster ride in just a few short sentences—now it's an endangered site as well? The video went on to say that the group was celebrating National Historic Preservation Month in 2012. That made me feel a little better knowing they were a part of a preservation group, plus that the video had just been released in 2012. This seemed like a good sign at least.

I could see behind the woman a sign attached to a window that read, "1847 limecrete structure." Whoa, 1847? That is amazing that this building was still there after 160 years. But I couldn't see the actual building yet. I wondered just how bad of shape it was in if it was listed as an endangered site. Then this pretty, petite, silver-haired woman in the next scene was seen holding a sign that read, "Discover Seguin's Hidden Gems." She softly said that she grew up right across the street from this building and played with the daughter of the last owner of the Magnolia. You could tell this woman cared about the building, as she said, "It needs a lot of help." Then they began showing scenes of the building. Although it did seem to be in very bad condition, at least it was still intact.

The video moved on to a man stating that he had played there as a child with the grandchildren of the owner. I was blown away because I knew

Poster of the "Top Ten Most Endangered Places in Texas," Magnolia Hotel. *Distributed by Preservation Texas.*

this man. He is a highly respected lawyer in Seguin. In his personal account of the hotel's past, he stated that there was a basement that he played in many times. He went on to say that "the founders of this city who started this place made it into a stagecoach stop in the 1800s." What? How could I have not known about this historic building?

They included several shots of old black-and-white photos of the hotel along with current ones. Now I could get a better idea of this building's condition, and it was indeed in very bad shape. Then this beautiful blonde is seen holding a sign that read, "Texas Ranger Jack Hays got married here." As an avid reader of Texas history, I most certainly knew who Jack Hays was. In my eyes, he was one of the greatest Texas Rangers of all time. What an honor for the city of Seguin to have had this great Texan married in its own hometown. One would think that the city would have boasted more about this incredible, historic event and what an even greater honor for this sad old building to claim. The woman went on to say something about a stump and where the bell from the Alamo hung for many years and that the Daughters of the Republic of Texas took it back. They stated that one of the actual bells that hung in the most famous Texas landmark of all had been on this property for years, yet it was related so matter-of-factly. From this mere three-minute amateur video, I had discovered some fascinating facts about this building. I wondered what more information was on it.

Although I was glad to see someone trying to save it, I was surprised the city had let it get to this point. Seguin had come across to me as a community that cared deeply about its local history. With the Magnolia Hotel being jam-packed with such fascinating historic facts, it was odd that it was on an endangered list. I wondered why the community would allow such neglect to this historic Texas landmark. Nevertheless, I wasn't looking to help save an old building. I only wanted to track the building down to get pictures taken for my book.

In the video, they didn't mention the address of this building they were desperately trying to rescue. Then I noticed how at the bottom of the video,

there was a picture of a man with the caption reading, "Video sponsored by a realtor in Seguin." Given that the video was sponsored by a realtor, maybe it was for sale. If so, I thought that perhaps if I showed enough interest in this endangered historic site, the realtor would give me the address to it. Better yet, maybe I could get a look inside the building. If so, I might get some interesting pictures from this visit. With that in mind, I looked up the realtor's website, found his number and proceeded to give him a call.

FINDING THE MAGNOLIA HOTEL

When the realtor answered the phone, it quickly hit me that I hadn't prepared what I was going to say to him in advance. Not wanting to lie, I simply said that we had seen the Main Street YouTube video he had sponsored and had some interest in the building. We were hoping to maybe view the property, if this could be arranged. Although he sounded excited in his reply of "How wonderful," there was still a sense of hesitation in his voice. He said that he knew the current owners of the building and would have to reach out to them and get back to me. I thought I blew it and that he was somehow on to me. All I could say was that it was not a problem and that I looked forward to hearing from him soon. Thinking he wasn't going to call me back, I was pretty disappointed. So, I got back to finishing the last chapter in my book as if I was not going to have a picture of the hotel after all.

A week or so had passed since my conversation with the realtor, and I had finished my *Haunted New Braunfels* book. The manuscript had been sent off, and I had made it just in the nick of time for my deadline. It was approved and sent off to press in time for its release a few weeks before Halloween 2012, which was not that far off.

I was excited to begin working on my next book, *Haunted Seguin*. I had given up all hope that the realtor would ever get back to me. It didn't matter now anyway, as the book had gone to press. A picture of the hotel would do me no good at this point.

Haunted New Braunfels cover. *Book cover photograph by Justin LeVier.*

Even though I kept wondering where this building was located, I had put it behind me. There was no need to think about this building any longer. The manuscript was now in the hands of the publisher. Emma's story was over for me; her tale had been told. Somehow, I still couldn't get her out of my mind. I wondered if people would continue to see this precious traveling spirit wandering the streets after I had shared her story publicly. I hoped not and prayed often that she might move to what I called "the light" and finally find peace. She and her good family deserved that. I wanted to believe that my sharing her story in my book would help them find that closure. In my heart, I thought only time would tell.

Although I was gearing up to write about Seguin's legends, the Magnolia Hotel was not one of them. All I had discovered on the building was a few historic facts—owning the Alamo bell, Hays getting married there and that it had been a stagecoach stop. The only mystery of a sort was that Emma's murderer had stayed there the night of the crime. With no paranormal accounts known, there was no reason to consider including the Magnolia Hotel, so it wasn't even on my location list.

My editor had not given me a break in between the two books, so I needed to concentrate on Seguin's history and legends. Plus, there was a huge book release party scheduled in a few weeks at the Phoenix Saloon. So, I began filing all the paperwork I had collected on New Braunfels except for one item: Emma's picture. I decided to keep that old black-and-white photo of Emma and even tacked it on my computer bulletin board. For some odd reason, I found it hard to let her go just yet. I kept having this overwhelming feeling that she wasn't ready to say goodbye to me too.

The next morning, as I was preparing to get to work on the next manuscript, I pulled out my large file of Seguin tidbits. Having lived in Seguin for five years, I had acquired a great deal of historic facts and local stories in my pastime. I must admit that I am a pack rat when it comes to history notes and publications. With all this information already at hand, the Seguin book

would be an easy task. It was just a matter of choosing which stories to write about and then do a little more research to confirm the accuracy of the names and dates.

As a fifth-generation Texan, the old times of Seguin were mesmerizing to me. The city's history involved many great Texans, and I felt truly honored to have lived there. One of my ancestors on my father's side was the greatest Texas Ranger of all time, William Alexander Anderson "Big Foot" Wallace. My father had told me numerous captivating stories about this great Texan during my childhood. To me, "Big Foot" Wallace was bigger than life itself. I saw this man as a fairy tale figure, and once I grew up, I was surprised to learn he was indeed a real person. Being related to "Big Foot" was one of my father's greatest sources of pride, and he instilled that in me as well. So, after learning that Seguin had actually been built by the original Texas Rangers, I became quite infatuated with this city.

I began reviewing my history notes on Seguin to freshen up my memory. I discovered that after the Texas Revolution, all the available land in Gonzales (where most of the Texas Rangers were from) had been scooped up by settlers before the Rangers returned. Some members of Matthew Caldwell's Gonzales Rangers sought out a new area to lay claim. There was a pleasant place along the Walnut Branch Creek that was a familiar location to these men. The Rangers had often gathered under the big oak trees as a meeting place during their patrols against raiding Indians and dangerous outlaws. Having a sense of belonging there to begin with, they decided that this might be a good place to call home. So, on August 12, 1838, three men founded a corporation to lay out the plans for a town to be called Walnut Springs. They were James Campbell, Matthew Caldwell and Arthur Swift. Later, they discovered that another colony had already claimed this name for their town. Then two men, James Campbell and John King, suggested the name be changed to Seguin after the patriot Juan Seguin.

While I was reading my notes on Seguin's history, the phone rang. I picked up the phone, and to my surprise, it was the realtor. In his friendly voice, he said, "Hi Erin, sorry it took so long to get back with you. I finally got a hold of the owner of the Magnolia Hotel. If you are available today, we could give you a walk-through of the building this afternoon." I told him, "You betcha!" and he gave me the address. Then I called Jim at work and told him that the realtor had arranged for us to see this mysterious building. Although there was no real purpose to view it since the New Braunfels book had already gone to press, we still wanted to satisfy our curiosity.

With the address hidden for so long now logged into my GPS, we started making our way to Seguin. As we turned the corner of South Crockett Street, right off the main street called Court Street, my mouth dropped to the bottom of the car floor. There it was! It looked exactly like it did in the newspaper clipping my sister had given me. This poor old building was in very bad condition. As we drove closer, I could see the white adobe-looking building in the back that the YouTube video had shown, noting that it was the original Magnolia Hotel. There were several cars parked up against the walls, just as close as they were in the picture. My first thought was, "My gosh, is this really part of the National Historic District?"

We could see a gentleman standing by the front door who appeared to be the realtor seen in the picture. After parking our car, we headed toward the realtor to make our hellos. He said that one of the owners would be there shortly. While waiting, he started up a conversation with Jim about where we were from, what type of work he does and so on. The whole time they were talking, I was looking around in awe. Was this building really built in the 1840s? The fact that it was still standing was hard to believe. It was definitely in need of a lot of help, but it looked considerably sturdy overall. Most of the window panes were missing, the exterior walls were

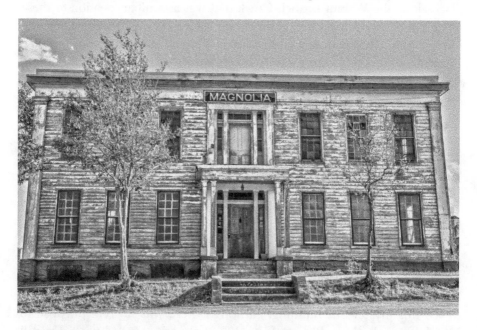

The Magnolia Hotel before restoration. *Photograph by Llamar Vasquez of Llamar Vasquez Photography, Seguin, Texas.*

practically down to raw wood from the paint peeling and the landscape was overgrown with unkempt trees and rubbish. Call me crazy but I could imagine what this building must have looked like during its grand heyday. The structure was just sad in my eyes, like a stray dog that had been roaming the streets alone for weeks. It just needed care and kindness, as well as a great deal of money.

While we were waiting for the owner to show up, I saw a wood sign that was placed next to a concrete stump that read, "*True Women* Tour." I asked what the sign was about, and the realtor stated that it was part of a tour that was created about the book *True Women*. How fascinating this seemed, but before I could inquire further, a petite blonde woman with a big smile walked up to greet us. She introduced herself and swiftly started sharing the history of the building. She was enthusiastic as she shared how the concrete stump at the end of the sidewalk had been there forever. It was used by the children at the hotel to stand on to ring the bell when the stagecoach arrived. She confirmed that the bell the kids would ring was the actual Alamo bell and that the Daughters of the Republic of Texas were given the bell back after fifty years or so. It was indeed now hanging back in the Alamo, where it belonged. She said that the building began as a simple two-room log cabin with a breezeway in the middle and was built by the co-founder of Seguin, Texas Ranger James Campbell. He was also the same man who helped change the city's name from Walnut Springs to Seguin. I was stunned. I had read about this man in my history notes. All these fabulous history facts about the building were given to us, and we hadn't even walked inside yet.

By now, Jim and I were intrigued because she was confirming everything the people in the YouTube video had said. As we walked around the cars parked on the sidewalks, there was a small gap where we were able to get to one of the doors on the side. As she began to turn the

HISTORY OF OLD ALAMO LIBERTY BELL IS NOTABLE

The old Alamo bell that is back at home for good and which was ringing at the Alamo before any of the people were born who are hearing it toll today has a notable history. It is the only one of the three original Alamo bells in existence. The other two were melted up. It has traveled thousands of miles and wandered from here to California since it was found in the San Antonio river in 1845.

It was discovered by Anton Lockmar, who gave it to the late John Twohig. Its genuineness as one of the original Alamo bells was authenticated by the Catholic clergy of San Fernando Cathedral.

In 1852 Twohig gave the bell to Major J. S. Calvert of Seguin, his father-in-law, and owner of the old Magnolia Hotel. The bell summoned the guests to their meals for years, remaining in the hotel till 1900. Major Calvert gave the historic bell to his daughter, Mrs. C. K. Johnston, and she in turn presented it to her youngest son, T. L. Johnston.

Then the bell went to California and took a look at many old missions, but none of them looked like the Alamo, and it may be that the bell felt lonely and wished to come back.

Anyway, Mrs. Joseph E. Dibrell became impressed with a deep enthusiasm to bring it home. She finally found that the bell could be bought, and opened negotiations with Mrs. T. L. Johnston to buy it for the Alamo and for the Daughters of the Texas Republic.

When the bell arrived at the railroad station, October 26, the following persons welcomed it: Mrs. Dibrell. Mrs. H. P. Drought, Mrs. T. A. Coleman, Miss Marin B. Fenwick, Miss McKay, Thomas H. Franklin, Leroy G. Denman, C. A. Oates and John Dancy Dibrell of Seguin.

They took the bell to the Alamo where the following committee welcomed it home: Mrs. Fannie Applewhite, custodian of the Alamo; Mrs. Q. M. Farnsworth, president of the Mission Chapter, Daughters of the Republic of Texas; Mrs. J. M. Kincaid, Mrs. L. O. Campbell, Mrs. J. A. Shirley, Mrs. Clayton S. Scott, granddaughter of the last President of the Texas Republic, Anson Jones; Mrs. Violet Haynes and Harry Hertzberg.

The package, containing the bell was placed on the old sundial and opened by Messrs. Franklin and Gates, and Mrs. Dibrell and Mrs. Farnsworth lifted it out.

Article stating that the Alamo bell once hung in front of the Magnolia Hotel. *From the* San Antonio Daily Express.

key to unlock the door, she said, "I grew up here with my two brothers, but it's been nearly twenty years since anyone's lived here." I marveled at how this poor old building has been vacant for that long. No wonder it seemed so sad to me. Then Jim, rather surprisingly to me, asked her if the house was haunted. This seemed funny at the time because Jim typically would turn to me if he wanted that type of information. He isn't one to openly inquire about this fringe subject. She looked at him, giggled and then said, "Nope. I was born and raised here and never met a ghost." She then turned back to the door, opened it and allowed me to go inside first then Jim.

The moment I stepped over the threshold I was quickly hit with a huge surge of energy to my chest. It made me gasp for air, and for a second I couldn't breathe. Jim grabbed my arm and asked if I was ok. I smiled and nodded my head. We then continued walking farther into the room. Although the room was wall to wall boxes, old furniture and other personal items, the space had the most beautiful feeling to it. The best way to explain it is that I felt as though the building had been holding its breath for a long time and was now exhaling a deep sigh of relief.

My entire body was tingling head to toe from the intense energy, as if I were in the middle of a happy group hug. It was the most welcoming feeling to experience. I turned to look at Jim to see if he was sensing anything, but he was only focusing on the layout of the building. Wanting whomever this was to know we were friends, I softly whispered, "I know you're here. I can feel you. Thank you for allowing us to visit your home." By the pleasant warmth of their energy, it was obvious they already knew we were friends.

The room we had entered had been a kitchen at one time. Along with numerous boxes, there was an antique stove, a refrigerator and a large porcelain sink along the wall. We could see several different layers of vintage wallpaper peeling off the walls and a large brick fireplace covered with soot from years of use. Coat after coat of paint was flaking off all the cabinet doors, and the flooring was green 1950s vinyl covering. Funnily enough, though, with the room being a kitchen, the smell of whiskey was very noticeable.

The owner guided us into the next room, which was just as overcrowded with boxes as the kitchen. The dirty lace curtains were flowing from the breeze coming through the missing window panes, giving it an eerie feeling. There was beaded wood along the bottom half of the walls covered in old paint that had bubbled from neglect. The realtor stated that this room was once part of the original 1840s stagecoach stop. One could just imagine the numerous lives that passed through this room in its 172 years of existence.

Then the owner said that while it may have been a stagecoach stop at one time, for her it was their living room. It was interesting to see the difference in the owner's and the realtor's images of the building. To the owner, this building had simply been her home where she grew up alongside her family, while the realtor described it as a hidden historic Texas landmark.

Then we were led to the other side of the stagecoach stop. It was just as overcrowded with old furniture and boxes as the previous rooms. The building appeared to have been a catch-all throughout the years. It was obvious that the roof had leaked at some point because there was extensive water damage to the ceiling and floors. But the structure of the building still seemed nicely intact. The building had that musty old museum smell that was overpowering at times. From room to room, the owner continued to offer up her family's past of living at this building. She shared how her grandparents had purchased the hotel in the 1930s and turned the ten-room hotel upstairs into four separate apartments. The downstairs had been converted into their home where she, her grandparents, parents and two brothers had lived. She was so upbeat and pleasant to listen to as she shared what it was like to have been a child growing up there. With much laughter, she shared how she had a pleasant upbringing while living there. She giggled about how hard it was at times for her grandmother to keep tabs on three teenage kids, two being boys at that. There was little mention of her parents other than that they had lived there too. I could tell that she was truly fond of her grandmother. As we were guided to each room, Jim and I were just mesmerized by this incredible building. Although we didn't know the entire history of the hotel, we did know it had stood in the center of this small city for more than 170 years. Being able to survive that long, it just seemed to have deserved better than the condition in which it was left. As we moved from each room, it felt like a maze. I was quickly getting turned around in my head.

Once we got to the last room on the bottom floor, Jim and I could see where the worst water damage had occurred. The old wood paneling covering the walls was coated with mildew. A ceiling fan dangling above was drooping from having been once waterlogged. On one side of the room there was a handicap handle by a box of switches and an AC unit in the window. There was a large gaping hole right through the wall where we could see stairs leading upward. This was definitely the worst room on the bottom floor. Around the room there were boxes on top of boxes and newspapers that almost reached the ceiling. The room resembled a hoarder's home and had an overwhelming melancholy feeling to it.

The owner quickly guided us through that room and led us to a door next to a gaping hole in the wall. I was glad that we kept moving, as I didn't care for that room's vibe at all. She opened the door to what looked like a dark closet. We were told to watch our heads and duck as we walked under a staircase. We had no idea where she was taking us. After a few steps, there was another door. I felt like Alice in the story *Alice in Wonderland* where the rooms got smaller and smaller with each turn of a doorknob. When the owner swung open the second door, the static flowing around the room was intense. This room definitely had the strongest feel of the bottom floor.

As we walked inside, we could see an antique fireplace in the middle of the room. We were now in the white adobe-looking house attached to the larger structure. She said this was the original Magnolia Hotel, built in 1846. It appeared to have been at least somewhat kept up compared to the rest of the building. This area had a considerably different feel to it than the other rooms in the larger building. I still sensed that delightful hospitable sensation, but the feeling of being hugged by a group was gone. This area felt less inhabited yet still had that feeling of acceptance with our presence. Of all the rooms we had been in so far, this one had the strongest energy.

The owner proudly pointed to the fireplace and said, "This is where Texas Ranger John 'Jack' Coffee Hays married his sweetheart, Susan Calvert. Her father, Jeremiah Strother Calvert, owned the hotel at that time." She stated that Jack and Susan met at the old Ranger Station not far from the Magnolia Hotel. My Texas roots made my heart swell with pride. I almost felt like saluting the fireplace in honor of this brave man's service to Texas. What a great story to be able to share. I just had to go touch the mantel. Right above the fireplace were the words "Home Sweet Home" molded into the wall with limecrete. It had the appearance of being made in the 1930s and gave the room such a welcoming feeling.

"Home Sweet Home" over fireplace. *Photograph by author.*

The owner explained how this part of the property had been a three-room hotel and then later became the servants' quarters. "The servants' quarters?" I asked. She replied, "Yes, when the hotel became so popular, they had a kitchen built outside. Then they brought the cooked food in here to be prepared for the guests arriving on the stagecoach. My grandparents later turned this building into an

apartment." Wow, this building just kept getting better and better. It made more sense now given the way the rooms were arranged. It looked like a small home instead of a hotel.

As we were led through a low square archway, one could see that the next room had been converted into a teeny tiny kitchen. I walked over to the kitchen sink to look out the window. All of a sudden, I got the most amazing sensation. It felt like someone had entered through the closed window and slowly walked right past me. I turned to glance at Jim with a surprised look on my face, and he gave me that "what?" expression. I just shook my head as if nothing was wrong, and we headed into the last room.

All three rooms of this small adobe-looking house were emanating a great deal of energy. The feeling of this area was simply exhilarating. I told Jim later that when we were exiting the building, it felt like someone was holding my hand as though they did not want me to leave. I hated walking away.

Soon we were back in that large and gloomy room. The owner said that we had to go outside to reach the stairway to the second floor. She unlocked the three deadbolts on the door and began pulling the door open. She was struggling with the door since the hinges had rusted shut, so Jim reached to assist her. We could tell this door had been kicked in a few times, which would be the reason for so many locks. Once the door was opened, we had to take a step back from the sudden unpleasant odor coming from the staircase. It reeked of stale alcohol and cigarette smoke. The stairway was filthy and creepy. Though hesitant, I followed behind Jim and our guides up to the second floor. With each step, I wondered if a rodent was going to jump out at me. The wooden planks of the stairs were crumbling from years of rain leaking down the walls. I tightly gripped the railing, hoping not to fall through. Once we reached the top of the stairs, the atmosphere of the building changed greatly. The air was heavy, and the overall sensation was dreary. The negative feeling caused me to stop and take a moment to catch my breath.

The first room had such a melancholy feel to it, and I was briefly overcome with a wave of depression. There were stacks of dirty boxes and empty, broken liquor bottles tossed about. At the base of one of the windows, there were several orange syringes exposed on the ledge. It was easy to see that this had been a location for drug users and very unbecoming sorts. The poor owner seemed embarrassed as she explained that with the building having been empty for so long, vagrants and undesirables would often break in and cause damage to the building—another reason for the numerous locks they had installed on the exterior doors.

The owner explained that before she was born, her grandmother had remodeled the once ten-room hotel into four small apartments to lease out. According to her, it was once a very lovely place to live. It was difficult to imagine that, given what we were confronted with. As we proceeded to the next room to our right, we realized that it was barely a complete room. The floor was rotted out from water damage, and the wall had a huge hole where we could actually see through to the outside. There was a bird's nest in the corner that seemed to have served many generations of barn swallows. We were swiftly warned not to enter unless we wanted to return to the bottom floor without even using the stairs. As I slowly poked my head around the door for a quick glance, I heard a woman's soft whisper say hello. Thinking it was possibly just the sound of the breeze coming through the broken window panes, I dismissed it.

We were led to another room, but for some reason, I couldn't walk over the threshold. It was like an invisible barrier keeping me from entering. I stayed back as Jim entered and observed the ceiling, badly damaged from years of roof leaks. The walls had been painted a horrible mustard yellow color, and the windows were nailed shut. Jim looked at me and asked if I was coming in, but I said, "Nope, I'm good."

We then went past what looked like a small kitchen and through a hallway. As we went farther into the center of the building, the horrible odor from human waste and mildew was a bit overwhelming at times. The owner guided us through a tight corridor, where she explained how the area had been closed off for use as closet space for the apartments. The wall separating the two apartments had been removed for easier access. Once we exited the passageway, the energy grew immensely. As we stood in front of a pink bathroom with a large claw-foot tub, the sense of sorrow was overpowering. Something profoundly sad had occurred here, although I had no clue what. I was compelled to whisper, "It is okay, we're not here to harm you. We're just here to visit your home." Although the grief-stricken energy was extremely strong, I was not afraid. I was simply taken aback by the intense unhappiness of the area.

As we continued our journey to the next room, the feeling of being watched by many was rather eerie. The unique vibe of each room was emotionally exhausting for me. One room would feel unhappy and the next one pleasant and inviting. The diverse temperament of each area gave a feeling of riding a roller coaster of moods and was a little hard to take in. I so badly wanted to just focus on the condition of the building itself, but the powerful energy surrounding me was difficult to avoid.

We noticed that the owner walked us more swiftly through the second floor than the bottom, and with no sentiment to this area at all. She didn't have any childhood memories to share with us regarding this floor. It made sense, though, as her family's home was on the bottom floor only. The second floor was leased out to other families, and the turnaround must have been frequent throughout the many years. We made our way from one side of the second floor to the other rather quickly. Then, when we came to a door located on the far left side of the fireplace, I got the oddest feeling. Even Jim reacted somewhat, which was unusual. I saw him make an expression on his face as if he had heard something and was trying to figure it out.

We went through the door, and on our left there was an exterior door but no balcony. If anyone were to exit the door, it would be a quick drop to the ground. The owner explained that there had once been a long covered balcony along the side of the building but that it had fallen down from neglect. How disappointing it must have been when the building's most stylish feature was destroyed. I thought how pleasant the balcony must have been on a cool Texas morning as one looked over the city square.

As we turned the corner, we could see another set of stairs leading down. All along the hallway of this staircase, from one end to the other, was graffiti. Jim made a comment of the rather impressive portrayal of Jimi Hendrix someone had drawn above the stairs: "At least one of the graffiti artists had good taste in music performers." We all giggled as we continued surveying the other interesting drawings on the walls.

Then we turned toward a small room that had the no. 3 written on the door. The walls had been wallpapered with old newspapers to cover up the holes. As I walked inside the tiny area, the strangest thing happened. Suddenly, everything grew silent, and I felt as though I was the only one in the room. No longer could I hear the voices of the other three people next to me, and the room was becoming dark. At first I thought I might be passing out. All I could see was a dim candlelight in the corner of the room. In front of the light was the dark silhouette of a man with his hand reaching out toward me. The feeling from the man was not threatening, so I kept trying to distinguish his face, but it was too dark. As I stepped to move closer to the man, I heard my name: "Erin. Erin." Then, all of a sudden, it was light again. When I cleared my head, I realized that it was Jim calling me. He said, "Are you coming with us or not?" I tried to shake off what had just happened to answer him. I quickly swallowed, smiled, stuttered the words "of course" and then joined the others as they walked down the stairs.

Once we were outside, the owner asked if we would like to see the 1840s Indian raid shelter. Both Jim and I were taken aback by this. Of course we said yes, definitely. We went to the back of the building, which was terribly overgrown with weeds. There were bars on the adobe-looking building's windows and old lawnmower parts everywhere. The back entranceway had used tires stored on it and rusty tin sheets nailed to the porch. She then pointed to a wooden board on the ground that was attached to an iron pulley on the exterior wall. As she pulled the rope, the plank opened up to a dark stairway and then a dirt floor basement. The basement was dark and dreary in appearance. The owner explained how this area was once an Indian raid shelter whenever the Comanche Indians were a threat to the settlers. During her time of living at the hotel, her grandmother used to have a kiln down here where she made pottery.

The owner said, "Well that's every inch of the property. Do you have any questions?" Jim and I looked at each other and said, "No, it is a remarkable piece of property. Thank you for letting us inside." She then got in her truck and waved as she drove off. The realtor turned to look at us, shook our hands and said, "What did you think?" Jim told him that it was an unbelievable building that definitely needed to be saved from further damage. Then both of us began feeling a little bit uncomfortable by the realtor's reaction. It was obvious by his big smile that he thought we were interested in buying the hotel. I started feeling guilty that we had not been clearer about our visit. I doubt he would have allowed us in just for the sake of pure curiosity. Even though we never stated what our real intentions were, we could tell the realtor was convinced we were possible buyers. So, Jim only said, "Thank

The Indian raid shelter.
Photograph by author.

you for setting this up. We really appreciate it." He gave us his card and said, "Hope to hear from you again in the near future." Then we parted ways.

On our ride home back to Austin, Jim and I went on and on about the building. The design of the structure was beautiful to us. It was easy for us to see beyond the damage of the interior. We both agreed that it needed to be rescued from further destruction, but it certainly wasn't going to be us. It was way too large of a project for us. We had actually been searching around for a small (and I repeat small) historic building that needed a little fixing up. A building with just enough renovation needed to become a fun weekend project together—that's what we were aiming for. Jim was beginning to think about retirement after thirty years of owning his own company. With our background, rescuing an old building seemed like the perfect way for the two of us to spend our lazy days together. Jim is an import/export broker as well as a preservationist, antiques restorer and muscle car collector. I am a retired museum curator, genealogist and history researcher. What better way to put our combined capabilities to use than by restoring an old structure.

Jim and I had actually located a perfect building to restore in Gonzales and were about to put an offer on it. It was small, had some history to it and needed minor work. What a difference these two buildings were in size and labor needed. We laughed at even the thought of taking on a project as big as the Magnolia Hotel. The building needed a great deal of work, tons of money and a full-time crew to get it up to working speed again. This project was definitely not meant for the two of us. For one thing, the building was way larger than what we were seeking. Our plan was to retire in the building we purchase to restore after it was finished. Gonzales seemed like a quiet, quaint town perfect for that. Although we did like Seguin, the Magnolia Hotel was way too big for just me and Jim. What would we do with all the excess space? Well, we both agreed that there was no need to even think about the hotel anymore. It was a "one and done" visit. Definitely a fun experience and we were glad we got to see the interior. By the time we got to our driveway in Austin, we had already changed the subject.

After being home for maybe an hour or so, I was in my study checking messages on my computer when Jim walked in and sat in the extra chair in my room. He said, "I didn't ask you this because I was waiting for you to volunteer what you thought. Since you hadn't mentioned anything yet, I'm very curious. Did you feel anything during our walk-through of the Magnolia Hotel? Were there ghostly boogie men lurking around every corner ready to pounce?" I laughed and said, "No, no ghostly boogie men.

But...." His eyes got bigger. "I did feel things." I could tell he wanted me to simply expand on this, so I shared everything that had happened. He asked me if I would consider it haunted given all I had felt. The experiences were not what I would call haunted, per se. I told him that it gave me more of an impression of residual energy. In my overall opinion, the house was simply pleased with our presence. I said, "I think the realtor was not the only one who was hoping we'd buy the building. I think the building wanted it too." He gave a slight grin, stood up and went back to watching TV in the living room. I assumed he had just been curious, but it was funny that he brought the hotel up again.

After a while, it was getting late, so we both headed off to bed. Jim fell right to sleep, but I tossed and turned. I kept thinking about the Magnolia Hotel and that strange feeling I had in room no. 3. The experience was rather odd for me. I wish I knew who the silhouette of the man was and why he was reaching out for me.

When sleep finally took me, the same intense dream I had been experiencing for years began again. The dream went exactly as it always had, from scene to scene, except this time there was something new. When I exited the building, I turned and look up to see the words "Magnolia Hotel" written on the top. The sound of a horse riding up to me made me turn to see who the rider was. As the horse rode closer, I could see it was the same silhouette of the man in room no. 3. Just as he got close enough to where I thought I would be able to distinguish his face, something woke me up. It was my Jim, rubbing my arm. As I wiped the sleep from my eyes, I noticed he had a freshly brewed cup of coffee in his hand. When I glanced at the clock, it was way earlier than we normally wake up. I asked him why the early wakeup call, and he said, "Because I wanted to talk to you about something. Drink your coffee, get dressed for the day and we'll discuss it on our drive backed to Seguin." I wondered, why Seguin? I'm supposed to work on my manuscript today. This was not in my plans for the day, but maybe he discovered a lead on a new ghost story for me. I slammed the coffee down and got dressed faster than ever. Once in the car, Jim said, "I've been thinking." Usually when he uses that line, it costs us money. So, I crossed my arms and said, "Ah, yes?" He chuckled and said, "I want to view the Magnolia Hotel again. I already called the realtor to let us in again. What do you think?" My first thought was that poor realtor is going to continue to get his hopes up, and we're going to pull the rug from underneath him with a big fat "never mind after all." I asked him, "Why would we want to take another run through of that building?" Then Jim said, "I don't know. I

would just like to see inside again." Funny, I really wanted to go back inside, too, so I was okay with this.

During the drive there, I told Jim about the extension to my dream I had that night and how the silhouette of the man rode up on a horse. He then turned to look at me and said, "I know this building is way bigger than what we were searching for, but it is incredible. Plus it's in Seguin, and you know how you love that city." I thought to myself, "Gosh, really? Are you really considering this?" I said, "But Jimmy, it's so huge!" This would be a far larger project than what we were seeking. So many questions ran through my mind as he continued with his thoughts. Although I was surprised by Jim's interest in this project, I could see in his face that he knew we could handle it. And if Jim thought this was doable, then it was. He never takes on a project unless he is certain it will be a success. Jim is not one for making rash decisions, so I needed to start giving this some serious thought and quick. The entire hour-long trip to Seguin, we volleyed our concerns back and forth. By the time we turned the corner to the hotel, we actually had a tentative plan of action.

We were going to offer the same amount we were prepared to spend on the building in Gonzales and take it from there. Jim told me not to get my hopes up too much. This building would need a vast amount of money to restore, so we could not go over our allotted budget, no matter how much we wanted it. He reminded me that the house in Gonzales would be more within our reach, including materials and labor to restore. The Magnolia Hotel restoration would require far more. Then Jim said, "Sweetheart, they are probably going to pass on our offer. Again, please don't get your hopes up." I smiled, kissed his cheek and promised I wouldn't. As we pulled up to the curb, there was the realtor standing on the porch with a kind, welcoming smile and a file of papers in his hand.

The three of us made our hellos, and once again we were allowed inside the building. Jim and I studied everything about the structure far more closely this time. I'm not sure why, but this time the building was quiet and still. There were no strange experiences during this visit. It felt as if the building was holding its breath in anticipation. We went from room to room, taking in every inch of the building, and it seemed even more incredible to us. After nearly an hour, we began heading outside to the backyard. As soon as I stepped outside the building, Jim turned his head toward me and nodded yes with his head. This was his way of giving the thumbs up to make an offer on the property. My heart started beating so fast I could hardly breathe.

As I tried to contain myself, Jim turned to the realtor and said that we would love to be the ones to rescue the Magnolia Hotel. He gave him our

offer, but then the realtor looked down at the ground as though disappointed. My first thought was that the offer was too low, and he was going to reject it. Then he raised his head and said, "Well, it's a good, fair offer, but the thing is…the building is not on the market." What? We were both so confused by this comment. If it wasn't on the market, then what was up with the YouTube video, the meeting of the owner and being given two showings of the building? He then said, "The owners have been approached by several buyers throughout the years but turned them down. Some of the offers were insultingly low, and others were turned down because of what they planned to convert the Magnolia Hotel into. This was once their home, where they were born and raised. The three siblings didn't want to see it become a restaurant or a honky-tonk bar. They sincerely would like to see the history of the building preserved." Jim and I both knew at that exact moment that someone beyond earth had a hand in this dealing. With our combined interest in preservation and history, we knew that we were the right people for this task.

The realtor explained how he would have to contact the owners again, let them know of our offer and get back with us. He told us good luck and shook our hands, and we said our goodbyes. I did not want to drive away in fear I'd never see it again. Jim could tell I was worried that the owners might pass on our offer. He said, "Stay positive." I nodded my head and then turned to take one last look at the hotel. When I did, I saw a figure of a man standing in the second-story corner window. I walked over to get a better look, but as I got closer, he vanished. I did not share what I saw with Jim. I just got in our car and headed back to Austin.

That night, my thoughts were consumed with the Magnolia Hotel. I desperately wanted to own that building. It was hard to empty my mind of it. I thought if I could mentally recall the layout of the building, it might help me fall asleep. I started at the front door and then walked from room to room. It worked, but now I was dreaming doing just that, walking around the hotel.

Each room I walked into had people, gathered together like a party going on. The ladies were all dressed in long gowns and the men in stiff collared shirts and dark jackets. The guests looked at me with welcoming smiles while raising their sherry glasses in a toasting motion. As I floated into each room, I got the impression that the party was being given for me, and it was delightful.

Then I heard someone call my name. As I turned around, there she was: little Emma. She ran toward me while giggling and gave me a long, tight

hug. It was such a beautiful feeling to have her in my arms. I took her chin in my hand and raised her face for a closer look, and she smiled. Then she put her tiny hand in mine and pulled me into the next room. The room was lit with a tremendously bright light, and I had to cover my eyes. As the light slowly dimmed, a figure of a woman in a long dress began to appear. Emma pulled at my clothing for me to look at her, and in a soft voice, she whispered, "Please help her." Her words tugged hard on my heartstrings. When I looked away from Emma to see who "she" was, suddenly I heard a loud noise. Not knowing if the crashing sound was in the dream or reality, it startled me enough to wake up. When I fully opened my eyes, I could see Jim standing near our closet. He had accidentally dropped one of his shoes while getting ready for his day.

He apologized for disturbing me and then walked over and sat on the edge of the bed. He asked how I was feeling. I told him, "Wonderful, but I had the strangest dream." As I shared this dream of Emma, he looked genuinely interested. He looked at me in such a pleasant manner and said, "She's trying to tell you something, but for now you need to focus on your book. Okay?" I knew he was right. For the next few weeks, I did nothing but write my manuscript, and the days were rather uneventful.

Soon, I had gotten a lot of writing done for the *Haunted Seguin* book and finally felt on track for my deadline. My big book signing event was all set up, and the packages of *Haunted New Braunfels* books were scheduled to arrive shortly. I was so looking forward to the book release party at the Phoenix Saloon. The owners were delightful people, and we looked forward to seeing them again. For the event, they were going to have a band playing before and after. They were even going to make a large batch of their famous chili for the guests to indulge in. My excitement was definitely gaining strength, and I was on cloud nine. Then, unfortunately, my happy bubble was burst by a simple phone call.

Jim called to say that the realtor had left a message to note that, sadly, the Magnolia Hotel owners had decided they weren't ready to sell the building. It felt like a ton of bricks had fallen down on me. My heart was crushed, and I kept thinking, "This can't be true." Why would life lure us to this crumbling historic building in hopes of rescuing it, only to be pushed away? Who then was going to save that amazing building? The deep sense of disappointment not just for us but for the building was overwhelming. When I asked Jim why they declined, he said, "I think they're just leery about our reason for buying the building." Then it occurred to me that maybe they just needed us to reassure them that we had nothing but good intentions for the hotel. With

that thought, I took a break from my book writing and composed a letter to the three siblings.

It roughly stated how we envisioned the future of the Magnolia Hotel under our care. It was important to make them aware of our background. We simply wanted to save this beautiful historical building while enjoying every minute of the discovery of its past. After writing the letter, Jim and I prayed together in the hopes this would ease the owners' minds. Jim looked at me and said, "It's in God's hands now, Sweetheart." I hit the send button, and it was off to the realtor for him to forward to the owners. All we could do now was wait.

OWNING THE MAGNOLIA HOTEL

Now that the owners had my letter in their inbox, there was nothing more we could do. As Jim said, "It is in God's hands now." The packages of *Haunted New Braunfels* books arrived, and we were headed to my big release party scheduled that evening. The excitement I felt at the Phoenix Saloon is something I will remember forever. I was finally going to share the stories my mom and grandmother had told me. I knew how fascinating these stories were to me, so I felt confident that they would be well received. Only one story gave me some concern: the murder of Emma. If my own grandmother had kept this horrific incident from me, how would others from New Braunfels handle this? I felt it was an important piece of New Braunfels's past that needed to be told. Plus, with all the unusual experiences I was having that involved Emma and the Magnolia Hotel, maybe this was this tiny spirit's way of seeking closure. This possibility gave me a great deal of comfort, so that's how I decided to look at it. My mother had conveyed to me that being given the ability to help spirits was a blessing, and to be able to offer these wandering souls' closure was the ultimate gift. I truly hoped that Emma would finally find peace now that her story was about to be shared with the world.

We arrived at the Phoenix Saloon to a packed house. Then the owner of the saloon walked up to me and said, "Erin! Is this wonderful or what? All these people are here for you!" All I could say was, "Really? Really?" He told me that people had been calling all day inquiring about the book release. I was dumbfounded! Then I wondered if they were here to confront me or to

congratulate me for sharing this city's legends. This question was answered quickly as I sat down. Everyone's reaction was positive and upbeat—it was wonderful. Many of these guests explained how their own grandparents had told these legends to them and how they had wondered if they were true. For the next few hours, I felt as though I was part of a family reunion, discovering relatives I had never met before. I did take note that with all these New Braunfels German descendants in the same room, no one mentioned ever being told of Emma's murder by their family. Well, except for one, that is.

This frail elderly woman stepped up to my table, but she didn't have a book in her hand for me to sign. I smiled and reached for one of my books thinking she was there to purchase one when the woman said, "That's not necessary. I'm not here to buy your book. I'm here to let you know you are walking on thin ice and you might want to be careful." I was stunned. Everyone had been so kind and pleasant up to this point. I didn't know what to say, so I just sat there for a moment with a blank expression on my face. Finally, I spoke and asked her, "I'm sorry but be careful of what?" With the coldest eyes and a straight face, she said, "You know exactly what I'm talking about." Then she turned and walked away. Jim was standing over by my in-laws, who were attending the event, and he could tell the woman had upset me. He rushed over to see what had happened. I told him I'd tell him later and that I was okay. Not wanting anyone to know I had a disgruntled visitor, I pretended nothing had happened. Thankfully, I was able to pull it off, and the rest of the evening went beautifully. Once I got home, though, I cried like a baby.

The old woman caused me such concern; it was very upsetting. I kept thinking, "What on earth could she have possibly been referring to?" Jim told me that I can't please everyone so this should not surprise me. I knew he was right, but it just left a mystery looming over my head. I felt more curiosity than anything.

A few days later, with the New Braunfels book now out there and doing very well, I was able to enjoy putting Seguin's legends together. I had finished several chapters by now and was working on the next when the phone rang. It was Jim with some very exciting news. He said that my letter had worked, and the owners had accepted our offer on the Magnolia Hotel. My scream of happiness must have been heard blocks away. This incredible dream was about to come true. Jim and I were actually going to own this amazing building. Then I thought, "Now what?" This was going to be a massive undertaking, and I'm right in the middle of writing a book. But we did say it was only a weekend project, so there was no need to hurry. "Take our time

and enjoy the journey" was our motto for this project. We must have said to each other, "It's just a hobby," a dozen times over the next few days while waiting for the paperwork.

Then, on March 1, 2013, Jim and I made our way to the title company located a few blocks away from the hotel. We both took a deep breath and signed the papers giving us ownership of the Magnolia Hotel. We were so excited. We were like little kids racing for the playground during recess at school. Before the ink was even completely dry on the title, Jim and I were headed over to the hotel with the keys in our hands. We parked the car in front of the building and ran to the front porch. Jim looked at me and said, "Are we crazy or what?" I told him, "Yes, but it's going to be magnificent." He turned the key and pushed open the door. The feeling of the building was the most beautiful feeling I have ever come across. I'm certain it knew it had just been rescued and that love had just walked through its doors.

Jim had purchased a bottle of champagne before we went to the title company and brought two glasses along. We went through every room as we made our way toward the back area. The original Magnolia Hotel (which we nicknamed "the adobe") in the back was the least filthy, so we wanted to make a toast to our new ownership in there. The atmosphere of every room we entered was delightful and nothing like our first visit. I've never come across such an enormous amount of positive vibes within a building. We finally made our way back to the adobe but had to open all the doors to it due to the musty smell. Even though it was grimy and dirty, to us it looked like a palace. Then Jim popped the cork on the champagne bottle and poured the celebration bubbly into the glasses. We raised our glasses for a toast. Jim said, "To the Magnolia Hotel, it's all ours."

Before we could take a sip of the drinks, a gust of wind came out of nowhere, startling us. Then, in a matter of seconds, all three doors slammed shut, and an ice-cold breeze went right between the two of us. We were so stunned that we just stared at each other for a while. Jim calmly took a sip of the champagne and then put his glass down on the mantel and said, "Well, so much for the building not being haunted by ghosts." All I could do was slowly nod my head. The only words I could muster were, "And this ghost is a doozy!"

THE HOTEL HAUNTINGS BEGIN

From that moment on, the spirit in the adobe was a regular guest. Every time we entered the room, her strong presence could be felt. Although she hadn't revealed herself yet, I would speak to her often, hoping for a response. It was just a matter of trust needing to be established. Although her energy was intense, it was definitely kind. For days as we cleaned out the filth in the adobe, her company could be felt as if supervising the project. After many weeks, we grew comfortable with this strong but kindhearted spirit. Before leaving for the day, we'd tell her goodbye and openly greet her upon returning. This female spirit had become part of the hotel and our daily lives. We were at ease with her company, and from the warmth of her presence, we assumed she approved of us.

After several months had passed, the adobe was now clean and had become our resting area. It was the place we took breaks in as we continued our restoration project. One afternoon during a brief break from clearing out the trash in the attic, I sat down to look over some of the artifacts we had found. We had discovered a small antique jewelry box tucked away in the corner of the attic. In the box was a man's World War II navy ring along with a few other interesting items. When I picked up the ring to bring it closer to my eyes, I heard a female voice whisper "save." Although I could not see her, I most definitely heard her. Calmly I replied, "Then I most certainly will." This was the first time she communicated, and it was thrilling. I knew progress was being made toward our friendship and that she would soon come forward. We placed the ring in a special artifact case and displayed it for all to see.

Then that special day arrived when I finally discovered who this strong female spirit was. I met a local author who had written a book about her Seguin ancestors. As a gift, she gave me a signed copy, which I brought to the Magnolia to read during my downtime. On one of those rare occasions, I sat down and opened the book. No sooner had I turned the first few pages than I could hear the spirit in the adobe softly laughing. This made me smile from ear to ear. Then, when I looked up from the book, there she was.

Smiling back at me was a petite frail African American woman with gray hair. Her appearance was only a matter of seconds and then she was gone, but it was a very clear manifestation. This was great progress, as now I knew she trusted me. If the book had triggered her appearance, maybe it had something to do with who she might be. I noticed the page of the book I had stopped at had a picture of a young African American woman with a caption of her name. I read the name Idella Lampkin out loud, and then I could hear her laughter became stronger. It was so pleasant hearing this female spirit express such happiness. As I sat there in awe of the fact that this spirit was now beginning to communicate with me, I asked, "Is this you? Are you Idella?" In a faint whisper, she replied, "Yes." I was blown away and had to fight from jumping up and down. It was hard to contain myself. Trying to maintain composure, I said, "Well hello, Miss Idella." Then the room was filled with the scent of gardenias. It was a day I will never forget. From that day, I looked forward to her presence and even missed her when I had to return home in Austin. After sharing with Jim what had happened, he felt it was nice to finally know her name now, and I had to agree.

Each day that passed, her presence grew stronger, and she was becoming almost like a friend to us. Thinking how much energy it must take for this spirit to communicate with me, I thought maybe there was a way I could possibly assist her. I remembered seeing a paranormal team use dowsing rods once during its investigation. I wondered if maybe this might help us to communicate. So I purchased a set, and at my next visit, I brought them with me into the adobe. I opened the package and placed the rods in my hands. Before I could even ask a question, I felt a massive surge of energy throughout my arms and hands. I was so startled I gasped and dropped the rods on the floor. The experience was so intense I had to take a seat for a moment to collect myself. As I was trying to regain my courage to try again, the atmosphere of the room became calm and pleasant. Then the room began to slowly fill with the sweet scent of gardenias. After growing accustomed to this ghostly fragrance, I knew it meant that Miss Idella was coming forward, and my fear began to melt away. As I reached down to

pick up the rods again, the room felt so tranquil. This time, once I gripped the rods, the energy was gentle. Although I could not see her, I knew that she was standing in front of me taking control of the situation. I know now that the initial intense tidal wave of energy had come from so many spirits wishing to communicate with me. It took Miss Idella to take control of the numerous spirits in the room and, later, the entire building. She was, without a doubt, the guardian of the building and regulated who and when a spirit could come forward to communicate with me.

I always knew that I had the slight gift of being a medium, though nothing like my mother. With the help of Miss Idella, the dowsing rods and the spirits of the Magnolia Hotel, that day made my spiritual intuition stronger than I ever knew possible. Sometimes I wonder if Miss Idella had a hand in this, or did I finally allow myself to accept what I always knew? All I know is that my spiritual awareness had been running at low power, but now, since that profound day, it was fully charged. Thereafter the spirits began to slowly come forward one at a time, and I was ready to assist them. The next one would be easier for me now that I knew I had help and was not alone on this ghostly journey. I was almost anxious to see who I was to meet next and if I could help them. It didn't take long before the next spirit came forward.

One evening, Jim and I stayed rather late clearing out the rubbish inside the hotel. As we were preparing to leave the adobe, Jim gathered up several items to bring home. With his arms full, I opened the door to walk out first while holding the door open for him. I turned to reach for the stuff Jim had in his hands when suddenly a male figure walked right between us. Jim stopped in his tracks and said, "Erin, did you see that?" He had the most astonished look on his face. Although I knew what he had seen, I wanted to hear his version first. I told him yes but asked what he saw. He said, "A

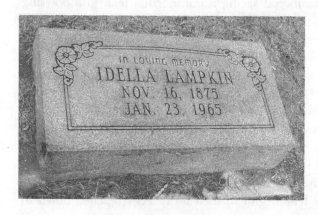

Headstone of Idella Lampkin, Seguin's fortuneteller.
Photograph by author.

man! A man wearing a cowboy hat just walked right between us and then disappeared." I confirmed with him that this was exactly what I saw too. Poor Jim, he looked at me and said, "We got another one?" After a tiny giggle, I nodded my head and said, "It sure looks that way." Jim just gave a deep sigh as he shook his head from side to side in disbelief.

We saw this man so many times that we eventually nicknamed him "the Cowboy." Later, we would discover that this spirit had been a passenger on the stagecoach headed to the Magnolia Hotel from San Antonio. For some unknown reason, during his ride to the hotel he kept trying to kill himself. The passengers tried to restrain him and keep him safe. At one point, he even jumped off the stagecoach and tried to drown himself. The stunned passengers pulled him out and then tied him up for his own safety. Once the stagecoach arrived at the Magnolia Hotel, he was untied, and everyone began going their separate ways. No sooner had they taken a few steps away from the stagecoach than the cowboy grabbed a gun and shot himself in the head. I tried numerous times to communicate with this ghost, but it became apparent that he was simply residual energy from the intense manner in which he died. We see him still quite often, but now we refer to him as "the Suicide Cowboy" when we tell his story.

This would not be the last of the paranormal experiences to come. It is said that remodeling an old building can stir up spirits that may exist. In the case of the Magnolia Hotel, it was more like a family reunion gathering, with the guests slowing arriving one by one. Each spirit showed up months or sometimes weeks apart, giving us time to adjust to their presence.

The next spirit to come forward in the adobe would be another female spirit. Her presence was quite different than Idella's. This spirit was reserved and her energy soft, whereas Idella's was strong. She mostly stayed in the kitchen area of the adobe. Sometimes she would loudly knock on the floor as if stomping her feet. Although she wasn't able to verbalize, we would communicate by using dowsing rods. By simple yes and no questions, we grew to know a few things about her. We knew that she never owned or worked at the Magnolia Hotel. As far as her name, the best we could clarify was that her name began with "F," so we nicknamed her "Miss F." Her favorite thing to do was to give me hugs with the dowsing rods and click them slowly together when happy. There was even a time when I was cooking a batch of chili on the stove that she tried to get me to add additional salt to the recipe by bumping my hand as I poured. The most common paranormal experience that happens inside the adobe kitchen is the feeling of someone walking right past you as you're washing dishes. The window over the

sink was once the entrance to the original 1846 hotel. They replaced the door with a window when it was remodeled in the '30s. It seems the spirits continue to use that as an entrance no matter what.

Jim also had an unusual experience once in the adobe. He dropped a coin on the floor, and it began to spin around in circles. Instead of the coin slowly losing momentum after a while, it gained speed. The circles grew larger, and it took longer than normal to finally fall. Once it did stop and fell to the ground, Jim tried to retrieve the coin, but it wouldn't budge. He said it felt as though someone was standing on it, not allowing him to pick it up.

When we finally had the adobe clean enough, we added a bedroom set so we could stay overnight comfortably. This is when we noticed that around 1:00 a.m., we could actually feel someone sit on the edge of our bed. Sometimes you could even see the bed sink in as though someone had just sat down. Quite often, we would catch a glimpse of a shadow figure sitting there, but never long enough to distinguish if male or female. The adobe became my favorite place in the entire hotel. It always had a comforting feeling about it, like I belonged there. I missed it when I left and counted the minutes until I could return.

During this miraculous time of owning the hotel, diving into clearing out the trash and restoring it, I was still in the midst of writing my *Haunted Seguin* book. Plus there were additional book signing events and media interviews to attend from the previous book. Needless to say, it was a whirlwind time in my life. Although it was difficult to balance everything, Magnolia's lure was hard to fight, so making time to spend there became high priority.

A CHILD'S VISIT

Our enthusiasm was fired up from owning this amazing building. We found ourselves spending every spare moment at the hotel. As each day passed, more and more unusual things continued to develop. It got to the point that these peculiar experiences became commonplace to us. We started to grow accustomed to the sounds of doors slamming, hearing furniture dragged across the room on the second floor, footsteps behind us and knocking on the walls. Seeing shadow figures became so frequent that we started acknowledging them with a jesting "caught you!" Jim would often hear his name called by a female voice when no one else was in the building. Oddly enough, they called him by my nickname for him, "Jimmy," instead of "Jim." There were so many spirits with their own unique characteristics that we began naming them.

The young African American boy whose picture was captured in the large mirror is called "Lil' John." He showed up often in the last room on the bottom floor. He enjoys tossing small pebbles at our unsuspecting guests whenever we had the door open to the backyard. His favorite target to tease was one of our caretakers. Lil' John's room is the area our stray cats like to sneak into. They always seem so at ease there. His own personal background is remarkable, and he's become a favorite of our guests.

Visitors to our hotel began capturing pictures of shadow figures, light anomalies and even faces in the windows. In today's vernacular, one would say that the ghosts were photobombing the guests. The most powerful photo captured was the stoic male face looking outward through the window on

the second floor. This man's image was captured in room no. 3, what we call the murderer's room. His expression showed no emotion or concern, as though his soul were empty. A group of people could all take the same picture of that room's window, yet no one would capture the same image. It was mindboggling, to say the least. Whenever I entered that room, the atmosphere would grow odd and the temperature heated. I knew I was not necessarily welcome in this room, but I was not going to be discouraged by this spirit's presence.

Now that the ghosts were becoming comfortable enough to be seen in pictures, it was just a matter of time before they began to communicate. Knowing that we were there to rescue their home was a comfort to them. This was proven by their stronger presence and longer visits. As the days passed, each spirit gradually made its identity known and began communicating in its own individual way. It seemed that the spirits were not only pleased that their home had been rescued but also relieved someone could actually comprehend their messages.

By now, we were aware that almost every room of the building had a spirit residing in it. Each had come forward gradually so as to not overwhelm us. It seems that even in their afterlife, they were kind and considerate. The Texas Ranger James Campbell, who was the original owner, enjoyed lingering in the gentlemen's smoke room. It was his log cabin home before he was brutally murdered by the Comanches in 1840. The sound of his boots walking across the room, the smell of his cigar and his rocking chair moving all by itself were commonplace.

Our antique hotel bell in the lobby is often tapped by unseen guests still wanting a room to rest in before getting back on the stagecoach. In the ballroom is young Sarah, who died in that room from a broken heart. Her sweetheart never arrived by stagecoach, as planned, to elope with her. Now she continues looking out the window in the hopes he will someday make his arrival.

Mrs. Read, the owner in 1850, continues to watch over the kitchen area, making certain that the hotel is run in top fashion. It is her that I butt heads with the most, given that we both want our kitchen a certain way. Eventually, we came to an agreement on how we could coexist without locking horns.

Although each spirit's identity was slowly being revealed and individual personalities were becoming apparent, their purpose for remaining was unclear. Since the spirits were growing to trust us, we felt it our duty to help uncover their reasons for being earthbound. In our hearts, we knew that some were reaching out for assistance. I felt a huge responsibility to aid

them in any way I could. I knew if I could learn more about the history of Seguin and the Magnolia Hotel's past owners, this could lead me to more information on our spirits' pasts. I had already gathered a great deal of info on Seguin for my book, but I refocused my attention on how the city's history involved the hotel. I spoke to locals, although many weren't even aware that the hotel existed. It was as if the building had been cloaked for years. It was also unusual that certain historians and societies extremely knowledgeable about Seguin's history never reached out to us or even visited. I couldn't figure out why they stayed clear of the hotel. Most of our initial information came from the realtor and the Seguin Main Street Organization.

Then, suddenly, people began showing up at the hotel's doorstep, wishing to share their ancestors' stories and how they were connected to the Magnolia. Out of curiosity, we started asking these visitors what brought them to the hotel and how they heard of our rescue efforts. Oddly, each one said that he or she just felt compelled—that an overwhelming urge to visit the hotel had overtaken them.

Even though we were knee deep in our restoration progress, we allowed numerous guests to enter. Most guests thought that the city had purchased the building and that it was open to the public instead of it being our private property. We didn't mind sharing the Magnolia with the curious, but we just weren't ready yet. Hating to turn people away, we began to set aside certain dates to allow people to visit. We started offering small group history tours on selected days, and they filled up quickly. Then a bizarre pattern began to unravel that was hard to ignore. Most guests attending our tours had some form of connection to the hotel but weren't aware of it at the time.

As certain guests entered, I could sense when they had a spiritual presence alongside them. My mom had taught me that everyone had a guardian angel protecting them and that sometimes these guardians can come forward to share something. At first, I was too nervous to allow myself to share what I felt in fear of being judged or ridiculed. I'd never offered spiritual readings outside my trusted circle, so I was quite nervous. It was difficult being able to sense the presence of their guardians when they came forward but didn't acknowledge them. Here they had made an effort to reach out with a message for our guests, yet I ignored them. My concern was being considered nuttier than a fruitcake. After watching what my own mother went through from judgmental nonbelievers, I was concerned how people would think of me. Then I remembered something my mother once said: "God gives the gift of sight for the sole purpose of helping others." All my life I gave to others, with no expectation of anything in return. Seeing their happiness was my

end goal. Although I was hurt often by my openhandedness, it pleased me to see my family and friends happy with my help. If someone began to take advantage of my generosity, I would simply step away from them. With that in mind, I thought, "Why stop now?" So, on our next tour, I decided to take a leap of faith and see if I could offer a reading to one of our guests. I took a deep breath and grabbed the dowsing rods. As I held the rods in my hands, the energy was powerful. Then I heard a soft voice say, "It's okay." It was that exact moment that changed my life forever.

I began to relax and meditated for several seconds, when suddenly, everything became quiet, calm and very clear. While holding the rods, I saw them beginning to turn toward the left side of the room. When I looked up to see which guest the rods were aiming at, I saw a stunning woman whose aura was a royal blue. I knew she was clairvoyant, with high spiritual energy, so I asked her, "What is your name?" She replied Tnisha. I then asked, "Why are you here?" The woman said, "I have no idea." I told her she was definitely here for a reason and would find out why very shortly. After several weeks, she later returned to tell me that she was a descendant of Idella Lampkin, if that meant anything. My mouth fell open, and I told her it was Miss Idella who had drawn her to the Magnolia Hotel. We had many conversations thereafter and have now become close friends. That day, Miss Idella helped me feel comfortable in conducting my first public reading and by luring in one of her own to assist.

From then on, I would offer readings on my tours if a spirit came forward. The need for using the dowsing rods lessened as my psychic ability grew stronger. Visitors from all around the United States began to inquire about our tours, but we had to limit them. We found ourselves working on the building at a much faster pace than planned. What was supposed to be just a hobby was now a full-blown restoration project. Every day, something unusual would happen at the hotel. The numerous spirits were becoming quite comfortable with us. We could hear humming, giggling and children's footsteps running throughout the bottom floor. This became a regular occurrence for us, and we actually looked forward to it.

In the top corner room of the second floor, we could hear a young girl constantly humming the "Itsy Bitsy Spider" song over and over. Her sweetness and innocence could be sensed as she murmured the tune. When she sought extra attention from us, she would slam her tiny closet door several times to draw us upstairs. We would later discover this young spirit's sad story and that her reason for humming the nursery song was because her name was Itzy.

One day, while Jim remained in Austin, I headed out to the Magnolia. I decided to work in the small room downstairs. As I began removing the last sheet of moldy wallpaper, a hidden door was revealed. Wanting to share this discovery with Jim, I reached for my cellphone to take a picture of the door. As soon as I raised the camera, the room became filled with children's laughter. Then I felt as though I had been time-warped back to my childhood and was now playing alongside other children in a school playground. It was incredible! I said, "I feel your presence" and then took the picture. When I looked at the picture, I saw something weird. I sat down on the floor to view the picture better. I could see the shape of a child right in front of my camera, a hand behind it and two fingers over the child's head in a teasing bunny rabbit gesture. I started laughing and told the little spirits how funny the picture was.

Then, when I looked up from the cellphone toward the doorway, I could not believe my eyes. There she was, standing right in the doorway of this room. It was little Emma Voelcker, the girl who had been murdered. Although she was more of a mental image, I could see her clearly as though she were alive and well. She was wearing her pretty dress seen in her picture and was just smiling at me. Although I wanted to say something, I just couldn't. I wasn't afraid, just completely taken aback by this strong image. As I sat there staring at this sweet child, the room began to smell of the scent of baby powder.

So many questions raced through my head. Why is she here? This is Seguin, not New Braunfels, and it's the building where her murderer had stayed the night of the crime. Did I leave something out of her story? Was she trying to tell me something? She just smiled at me and then swiftly turned and skipped away. I jumped to my feet to run after her, but she was gone. Why on earth would this young spirit come to visit me at the Magnolia Hotel? I quickly called Jim to share what had happened, as well as to help me calm down. He felt it best that I come home, and the entire drive back I was in a state of confusion.

I worried that maybe I hadn't told her story correctly or that I might have left something out. Was she upset that I was rescuing the building where her murderer had stayed the night of the crime? Her smile had been so sweet when she looked at me. In my heart, I felt she was more pleased with me than upset. If that was the case, then what was her reason for visiting me?

I didn't go back to the Magnolia for several days because I was worried that I'd see her again. I was concerned that I had let her down in some way. Jim said that she was probably just thanking me for sharing her story, but it

sure felt like more to me. I used the few days at home to get caught up on my Seguin book, which I was overdue on completing. Maybe Jim was right and that it was probably a onetime visit. Eventually, I decided to buck up and head back to the hotel. Once I was there, I was a little nervous, so I went into the adobe section, where I felt most comfortable. The energy in those three small rooms was always pleasant, and I needed that today.

I picked up my dowsing rods just to see what would happen, and I could sense a presence right away. I asked if it was Idella, but there was no response. Then I asked if it was Miss "F," and the rods moved. I shared with her that a spirit named Emma had visited me in the small room, and the rods grew intense with warm energy. I asked if she had known the child, and the rods noted yes. Then, abruptly, the rods grew cold, and I knew the spirit had pulled back fast. I lowered the rods and made my way toward the small room we now called the "children's room." As I rounded the corner of Lil' John's room, I could smell the fragrance of baby powder and the presence of a spirit extraordinarily strong. I stopped, closed my eyes and told myself to get a grip. I kept saying a prayer that Emma would not be there. As I slowly began to open my eyes, I could hear giggles and then…there she was again. I quickly closed my eyes again and then slumped my shoulders in disappointment and sighed. I kept whispering softly to myself, "Get a grip, girl. Get a grip." Then I fully opened my eyes. She was so angelic looking as she smiled at me. Down by her side, she was holding a handmade rag doll in her hand. When I moved toward her, she giggled and then vanished into thin air. I had a feeling that this was going to be a regular occurrence until we got used to each other. I'm certain she was just as apprehensive as I was. We both just needed more time.

This type of visitation continued for many weeks, and each time, she stayed a little longer. I'd see her skipping throughout the bottom floor. Jim could hear her giggles and the sounds of her tiny footsteps. She'd call his name, and it was hysterical watching Jim's surprised expressions. Then we began to hear several children softly singing in the children's room. I would discover that Itzy would come down from upstairs to play with Emma and the other two young spirits, William and Jennie, who later came forward. Oddly, the children's room always has the smell of baby powder in that area. It is a constant reminder that the Magnolia angels were happy in this tiny room. I grew accustomed to their presence and looked forward to their visits.

I noticed that Emma never came forward when there were other people in the building. As soon as a stranger would enter, she'd leave. That held true until we allowed a paranormal team that had become close friends of

ours to investigate the building. One of the male team members placed a ball in the children's room and taped a square around the ball. He asked me if I felt her presence yet, and I said no. Then he asked Emma if she would like to play with the ball. To my surprise, she came forward, and the room filled with her scent of baby powder. He asked Emma if she could move the ball. Although this time I could not see her, I felt her right by my side. The team member once again asked if she could move the ball. Right in front of Jim, me and the two team members, she moved the ball forward. Everyone freaked out and screamed with excitement. The room was energized, and I was so proud of her. Jim said it was because she trusted me—if I said it was okay, then it would be.

From then on, she would often come forward around certain guests and enjoyed entertaining them. She began to move a pinwheel, tug on a feather and turn a light on and off when asked a question. She and I were becoming close friends, although she had not yet communicated with me. It was obvious that she was seeking something from me, but I still didn't know what. To be honest, it didn't matter—I loved her presence, and she could stay as long as she liked.

JUSTICE SERVED

Just after Halloween, I was scheduled to do a small *Haunted New Braunfels* book signing at a San Antonio location. When we got there, the owner gave us a spot alongside another author attending. There were only a handful of people there, so it was a casual gathering. Then a paranormal film crew walked in asking if it could conduct an impromptu interview with me. I was delighted to do it since hardly anyone had shown up for the book signing. While the crew was setting up the cameras, the owner of the venue said that there was a lady there to speak with me and she wasn't too happy. Although I had no clue why this woman would be upset with me, I agreed to speak with her. Then, this stunning woman walks in and sits next to me. Jim and my mother-in-law, Billie, joined me to hear what she had to say. She began by saying that she read my New Braunfels book and asked if I would not disclose the location of William Faust's burial site. She stated that in the past, his headstone had been shattered, and she didn't want this to happen again. I was a bit confused by this conversation. I asked, since she was protecting Faust's headstone, if she was related to him. Then she grinned and politely said, "No, I'm a descendant of the Voelckers. We felt a sense of remorse for him, his wife and in-laws on how it all ended."

I was dumbfounded. Here her ancestor had been murdered by Faust, and she felt sorry for him and his in-laws? I turned to Jim and Billie, and they looked just as confused as me. I took a few seconds to try and comprehend what she was trying to get across. Then I asked what she meant by "how it all ended." In a matter of seconds, she spoke the words that answered

everything. She looked me right in the eyes with such kindness and said, "It was Emma's father, Julius Voelcker, who shot William Faust to death through the courthouse window. The sheriff had moved Faust to the least protected area to allow the child's father to take vengeance while nearly forty men stood guard. If you think about it, the sheriff never looked for Faust's killer, and the town was ok with that. It was a hush-hush topic no one ever spoke of after Faust's death."

There it was. The reason Jim and I were sent to rescue the Magnolia Hotel was at the behest of a young spirit determined to tell the world the truth. Emma had guided me and Jim to locate a building that held the spirit of her murderer to help reveal her secret. She wanted to let the world know that in her father's eyes, justice had been served by taking matters into his own hands. By now I was in tears. Here this lovely woman had taken the time to share a dark family secret, and she had no idea how profound her message was. I was speechless, which was awful since the film crew quickly walked up to us and said, "Okay, let's roll." The crew had no idea what had just been shared between me and the woman. I quickly shook off my emotions and gave the interview, and this lovely lady actually sat next to me during the process.

On our drive home after the book signing, Jim and I discussed what we had heard. Although her ancestor Julius Voelcker had shot and killed Faust, why would her family still feel compelled to watch over the murderer's grave site? Yes, Julius killed Faust, but the man had murdered his only daughter. Back then, vigilante justice was more common. Why would her family still feel a sense of remorse for Faust and his in-laws? We both agreed that this was an unusual sentiment but let it go at that. We agreed that little Emma had sent the mysterious woman I met at the library to tell me of the Traveling Ghost. She then sent me to the museum, where I discovered her files. It became a domino effect after that. The Magnolia Hotel would be her next stop for us, and she probably had a hand in getting the building's owners to agree to sell it to us. Had it not been for Emma guiding us, her family secret might never have been revealed. What an accomplishment for this little spirit. She set out to prove that her father's act of revenge was within his rights and had corrected the wrong of his child's death. Now Emma was using my authorship to share that secret with the world. I promised Emma that I would share her secret in my *Haunted Seguin* book.

As soon as I walked through the door of our home, I ran to the computer and typed up the story. I inserted it as chapter 4, the same as Emma's first story in *Haunted New Braunfels*. The next day, we headed over to the hotel.

We both walked in, and I called out for Emma, hoping that she was there. I walked throughout the bottom floor of the building sharing what we had discovered. I told her that we knew her secret and that it would be revealed in my book. However, she wasn't present, which seemed odd. We thought she would be happy to hear our revelation. Then it hit me: maybe now that we know the truth, she no longer needed to visit us. Now that her secret was out, maybe she had finally gone to the light. Suddenly I felt a roller coaster of feelings. A part of my heart hoped this to be true and that she was finally at peace. Another part was going to be broken and miss her dearly.

As I strolled from room to room, continuing to share everything her descendant had shared, I noticed how still the hotel was. It felt as if every spirit in the building was taking a moment of silence. Even the spirits in the adobe had pulled back, which was odd. I wondered if Emma's secret had been all of the spirits' reasons for coming forward. Had they all been trying to get this message across? It was a bittersweet day for me. Though grateful for discovering the truth, I thought maybe all of the spirits had moved on. It was funny how close I had gotten to them. They had, in an odd way, become almost a second family to me. Did I lose them all at once? After a few hours, I headed back home to Austin. I decided that I would not return to the hotel until I had finished my manuscript, which I did. The editor chose the Magnolia Hotel for the cover, and it went off to print. The book would be released soon, and Emma's secret would be known. It was a good feeling knowing that not only was my book finished but also her secret would be known by everyone soon. Now my plans were to focus on preparing for the official launch of my next book and the grand opening of the hotel. Needless to say, I slept very well that night.

The day my book was being released had finally arrived. We held a huge event at a theater across from the hotel and featured a documentary called *Emma's Little Secret*. The film was a two-part episode that was featured on PBS. It was produced by Billy Driver and Mark Morrow of the paranormal team called Strange Town. After the film, guests were invited over to view the first two rooms of the Magnolia Hotel that had been completed, and my books were also available for purchase. The turnout was far larger than what we ever expected, and we quickly sold out of books. I kept thinking that everyone will know Emma's secret now. I felt good about helping Miss Emma reach her goal, but I was already missing her. The event lasted very late into the evening, and it was a huge success.

The next day, we returned to the hotel to tidy up the mess from the night before. By now, many would have read her chapter in my book. Since she

Haunted Seguin cover. *Book cover photograph by Megan Foster, Seguin, Texas, meganfosterphotography.com.*

hadn't shown up, I found myself almost grieving, suspecting that she might no longer visit. I missed her as if she had always been a part of my life. As I walked toward the back of the building with the bag of trash from the event, I paused at the hallway leading into the children's room. I was missing her so much that I almost turned around to go through the other room. Then, suddenly, the scent of baby powder filled the room. I dropped the bag and bolted for the children's room. Knowing what this meant, I sat down in the chair. I held my breath, anticipating her appearance. Then, there she was. She hadn't left after all. I didn't know whether to laugh or cry. I told her how delighted I was that she was here and how I missed her. I could sense her happiness. It didn't feel right to inquire as to why she hadn't been around or why she still remained, so I let it go. If she wanted to stick around, it was okay with us. We loved having her, and so did the other spirits within the building. From that day forward, Emma's presence would actually become stronger and her visits more frequent. Although this was the exact opposite of what I had expected after sharing her secret, we cherished every second of her visits.

Every month that passed thereafter, our relationship grew stronger. Emma was now capable of communicating with me. When she spoke, it came silently, as if it was my own thoughts coming through. She would respond via single words or names. One example occurred when we conducted an evening tour; she would whisper a name to me, and it would be one of our guests. When I would share the name, it was delightful to watch how she would dedicate the moving of her ball to that person. Although she didn't attend every time, Emma had become a part of the tour, and she loved it.

THE SECRET OF TWO CITIES

With my writing behind me, Jim and I were excited about having more free time for us. We couldn't wait to dive into working on restoring the hotel, but that downtime didn't last long. The news of the Magnolia Hotel being haunted hit the paranormal grapevine at lightning speed. Soon we had people from national cable stations wanting to visit. We had *Ghost Adventures*, *Ghost Adventures Aftershocks*, *Ghost Brothers*, *Nick Groff's Tour* and *When Ghosts Attack* wanting to film at the hotel. We were even featured in national magazines such as *Country Living*, *True West*, *Texas Highways* and *Cowboys and Indians*, and we were interviewed on the *Darkness Radio Show*. Local newspapers and evening TV news shows began knocking on our door too. Jim and I were not prepared for this heightened popularity. Our quaint weekend project was now front-page news and on every paranormal enthusiast's lips.

While trying to restore the building, we had to learn how to handle this unexpected media exposure. Being thrust into the public eye so suddenly was not something we had considered. We really didn't have a clue what our intentions were for the future of the Magnolia, but we figured this media exposure could prove useful someday. So, while we were working on the hotel, we allowed interviews and filming to take place. Most of these opportunities were helpful, while others we wished we could erase from the public eye. Needless to say, it was a whirlwind time of our life. Also during this time, additional spirits were coming forward. Almost every room of the building had at least one spirit residing in it, and these spirits

were anxious to share their stories. In one room, there was the spirit of a traveling salesman who committed suicide in a horrible manner. His name was JJ, and although he continues to reside in that room, he is most pleasant to communicate with. We were up to the count of thirteen ghosts, with more still coming forward.

Throughout this entire time, Emma would show up to watch the excitement of people learning more about her story. When TV shows used reenactors who resembled Emma, we could hear her giggles throughout the building. She grew comfortable around our tour visitors and our resident actors and loved it when children showed up. With so many media outlets sharing Emma's story, she actually developed a fan club of sorts. People began leaving toys on our doorsteps for Emma, so we brought in a small toy box for her collection. It was wonderful to see how loved this young child was even after her death.

During our restoration, we continued to allow visitors into our now weekend home. Everyone wanted to see our restoration efforts of this once abandoned eyesore, plus maybe get a glimpse of a ghost along the way. The building's spirits never failed to amuse our guests. With so many spirits still residing within the hotel, one or more would show up for our evening ghost tours. Afterward, Jim and I would walk around the rooms thanking the spirits for entertaining our visitors. The income from our tours was helping to cover the phenomenal expenses of restoring this 175-year-old Texas landmark. Every single penny from the tours went right back into restoring the hotel. There was a time when we thought we might have to end the restoration because of the mounting costs. Had it not been for the presence of the spirits, that might have been the case. In my heart, I truly believe the spirits knew that this was a way they could help out.

As the months and then years passed, we continued with our restoration progress while giving tours on the weekends. By now we had restored the entire bottom floor. The results were stunning with the fresh coats of paint, ceilings and walls repaired, wood floors stripped and stained. After four years, the building was now really starting to feel like it did during its glory days from 1850 to 1890. We were enjoying bringing in furniture and hanging pictures, making it feel more like a home. We would open our doors to the public for free whenever the city had special events going on. The Magnolia Hotel had become very popular with the help of the media outlets. Our guided ghost tours were selling out faster than we could keep up with. Things were running pretty smoothly. We were beginning to finally relax and enjoy our so-called weekend project. The adobe had now become

our private residence, with central air and heat. The numerous spirits within the walls of the hotel had become permanent guests, and we treated them as such. We found ourselves spending more time at the hotel than our own home. It felt as if we had finally gotten our hobby on track, or so we thought.

One day, while Jim and I were returning from a trip to San Antonio, we were passing through Selma. I felt an overwhelming desire to finally visit the grave site of Helene Faust. I asked Jim if we could make a quick stop to her grave, and he reminded me that William was buried right next to her. He asked if I could handle being so near the person who killed our dear Emma. I told him it would be all right; if I became uncomfortable, I'd walk away. The urge to visit Helene was so strong that I didn't give William much thought. Helene had been a victim at the hands of her husband's rage, too, but for some reason, she never entered my mind. With all my focus being on Emma, I hadn't considered how this tragedy must have affected Helene too. I'm certain that Helene's life had been drastically changed after the attack. Although she survived her injury, she would never see again. The strike across her face with the axe left her completely blind and at the mercy of others to care for her. Her once beautiful appearance had been severely mutilated. I can't even begin to imagine the pain this woman must have endured.

Helene had grown to love Emma through their friendship, and on that horrific night, she lost her sight and her dear friend and became known as the wife of a murderer. Since she never saw who had killed Emma and blinded her, she vowed to her dying day that her husband was innocent. The ugly gossip must have been hard to avoid. I found myself feeling deeply sad for this poor woman. We had never been to her grave site before, so we had to rely on a hand-drawn map given to us by a friend. Then something strange happened. As we exited the highway, I was able to guide Jim right to her site without even looking at the map. Jim asked if I was sure I had never been here before, and I told him I was certain. It was as though she was mentally leading us to her.

No sooner had we turned the last corner nearing the cemetery than a strong presence could be felt inside our truck. Even Jim could feel the unusual atmosphere and asked what it was. I told Jim to drive faster, and I nearly jumped out of the car before stopping in front of the site. Jim asked me what was going on, and I told him that she was calling me. The urge to get to her headstone was unbelievably intense, so I ran to it. Her tiny site was badly overgrown with weeds, but we pushed right through to get to her. Once we reached her headstone, I bent to the ground and hugged her headstone.

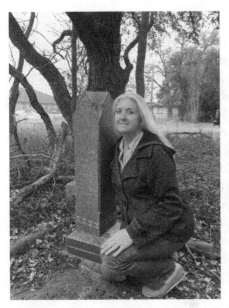

Left: Helene Faust's headstone. *Right*: William Faust's headstone. *Photographs by Jim Ghedi.*

Poor Jim, he was so confused. He asked, "What are you feeling, sweetheart?" I told him, "This is crazy; she is so happy to see us." The warmth from her presence was joyous and kind. It felt as if her arms were around my shoulders, and all I could say was, "We're here, we're here."

As I sat there, hugging her headstone and hoping no one was watching me, I could sense that she was trying to tell me something. I tried hard to understand what it was. My dear Jim knelt down next to me and asked if I was all right. I told him yes but that she has been waiting for this moment for a very long time. Helene was thrilled to see us. The feeling was wonderful. Jim began removing a large branch that had fallen over her grave site and pulled some of the high weeds around it. Then I heard him say, "Look, Erin."

When I looked over toward him, he was pointing his finger downward. He again said, "Look." Although I hated releasing the feeling of Helene's presence, I stood up and went over to him. The ground was covered with dead vines and leaves, but I could see something underneath it all. Then Jim said, "It's Faust. Here's his headstone." The slab had been shattered into pieces by vandals but was still legible. We looked at each other as we realized it had just become very real for us. We were finally standing in front of the grave site of the man whose act of violence changed the path of so

many people's lives, including our own. The resting place of the cruel man who killed sweet Emma and blinded Helene was right in front of us. I was waiting for some sort of negative reaction toward us from possibly Faust's presence, but nothing happened. All I felt was my own private anger and hostility toward him. How Helene could bury this monster in her own family plot was unthinkable in my opinion. I know love can be blind at times, but this was a little too far-fetched for me to understand. I couldn't look at his headstone any longer, so I turned my attention back to Helene's site.

Jim asked if I was okay, and I nodded yes. When I went back over to Helene's site, something amazing happened. It felt as though I had hit an invisible wall, and I knew she was standing right in front of me. Then I heard a woman's soft voice say something. I looked at Jim quick, and he asked, "What?" I put my finger over my lips to say hush and listened intently. There it was again, the woman's voice, but this time I understood a word. The voice said, "pages." I asked out loud, "Pages? What pages?" The voice then said, "Turn the pages." Although I had no idea what this meant, it was a message from her, and I was ecstatic. It was hard to contain myself. I was about to ask another question when suddenly her presence was gone, and I knew she had pulled back. Jim kept looking at me with that "What's up" look. I told him she gave me a message and that we needed to help her. The fact that Helene came forward and gave a message too was just astounding. It was getting dark, so we had to get going. We first looked around for some wildflowers and then laid them on her grave site. Jim and I both said goodbye to her before we walked away. The entire drive home, I kept thinking about her message and what it could possibly mean.

That evening, while lying in bed, I kept repeating her words, "Turn the pages." Then it hit me like a ton of bricks. I realized that in my New Braunfels book, I had shared how Emma's murder occurred, who did it and Emma's secret of how Faust was killed by her father, but I never researched what happened afterward. I had no reason to look beyond these events. My publisher's goal in these books was to just share ghost tales in these two cities, not solve them. Emma was dead, Helene was blinded and Faust was killed—case closed. I had accomplished what was wanted of me and left it at that. Out of curiosity as a genealogist, I did research Emma and Helene's family line to see if there were any connections to mine or the Magnolia Hotel. Since Helene kept saying, "Turn the pages," I thought maybe something happened to her after William's death that I wasn't aware of. So, at 2:00 a.m., I got up and began researching online history sites for the dates after William was killed.

After an hour, I was beginning to lose steam when I landed on a newspaper article that caught my eye with the headline reading, "The Faust Murder June 26, 1879." Gosh, this was three years after William's killing. I wondered what this was about. As I read the article, each word caused my heart great pain and sorrow. I began to cry as I experienced a wave of emotions. As the tears rolled down my cheeks, all I could say was, "It can't be. It can't be." I knew this was Helene's reason for calling me to her grave site and what her message meant. I now knew without a doubt why sweet Emma had led us to the Magnolia Hotel and why she continued to visit us. Jim ran in and asked what was wrong. I told him, "I have to fix this, sweetheart. I have to correct this." He then asked me, "Fix what, darling?" Holding my tears back, I read him the article:

> *At last the murderer of Mr. Faust in New Braunfels comes to a death bed and confesses committing one of the most horrible crimes on record. The Gonzales Index tells the story as follows: Five years ago while Mrs. Faust and Miss Voelcker were sleeping alone in a house at New Braunfels, an assassin stole in with an axe and killed Miss Voelcker and dangerously wounded Mrs. Faust. The husband of the latter lady, who was absent at the time, was arrested on suspicion of being the murderer, and while lying in jail awaiting the action of the law was taken out and brutally shot by a mob. Last week a man named M.P. Deavors died in Bandera County, and just before his death confessed the murder of Miss Voelcker. He was at this time an itinerant music teacher, and taught vocal music in Gonzales for a time, having with him two little girls, a little boy and a nephew. He confesses the deed was committed with the intention of robbing the house. The man who brutally shot poor Faust will now admit that he was a better man than he was, and he should begin the work of repentance as soon as possible. The* States-Man *gave a full account of the murder a day or two after it was committed.*

Jim looked at me with such sadness in his eyes and then bent down to hug me for the longest time. As I continued to weep, he said, "We'll fix this. Don't worry. We'll fix this. Emma, Helene and now William have been waiting for you to come along for a very long time, and we'll fix this." All I could do was nod my head and cry. My heart hurt so badly. Here I had been telling Emma and Helene's story with the ending that it was William Faust who had committed the murder, and now I discovered he was innocent. Everything about how the actual crime was committed was

THE FAUST MURDER.—At last the murderer of Mrs. Faust in New Braunfels comes to a death bed and confesses committing one of the most horrible crimes on record. The Gonzales *Inquirer* tells the story as follows: "Five years ago, while Mrs. Faust and Miss Voelker were sleeping alone in a house at New Braunfels, an assassin stole in with an axe and killed Miss Voelker and dangerously wounded Mrs. Faust. The husband of the latter lady, who was absent at the time, was arrested on suspicion of being the murderer, and while lying in jail awaiting the action of the law was taken out and brutally shot by a mob. Last week a man named M. P. Deavors died in Bandera county, and just before his death he confessed the murder of Miss Voelker. He was at this time an itinerant music teacher, and taught vocal music in Gonzales for a time, having with him two little girls, a little boy and a nephew. He confesses the deed was committed with the intention of robbing the house." The men who brutally shot poor Faust will now admit that he was a better man than they were, and they should begin the work of repentance as soon as possible. The STATESMAN gave a full account of the murder a day or two after it was committed.

Article proving Faust's innocence. *From the* San Antonio Express.

true, but the wrong man had been accused. By now, it was nearly 4:00 a.m., so we headed back to bed and I cried myself to sleep.

The next morning, we drove back to William's and Helene's grave sites to pay our respects. We both felt a sense of obligation to let them know what we had found. This time, when we parked near their grave sites, the pull was even stronger to hurry to Helene's headstone. I raced over to it and could sense her presence. I knelt down to hug her headstone and told her that I knew the truth now. Jim asked if I felt anything. "Happiness, Jimmy. She is feeling pure happiness," I said. Jim smiled and then went over to William's grave site and started clearing up his area. Then he asked me, "What about William? Do you feel anything?" At first I was hesitant to go over to his site. I was so disappointed that I had not helped him sooner. I almost felt ashamed. Then Jim said, "Come here, Erin. I'm with you. Tell me what you feel." I walked over to his site and knelt beside it. I said, "I'm sorry, William. I will correct this. The truth will be told, William. I promise." What happened next is hard to describe. At first, it felt as though he was frightened to come forward, like a child afraid to take their first steps. His energy would come forward slowly and then quickly pull back. He did this several times, and then my sweet Jimmy said, "You can trust her, William. She believes in your innocence." As soon as he said that, I felt the warmth of a long embrace. I repeated myself and said, "I will correct this wrong, William. The truth will be told." I sat there for a while as Jim continued to tidy the area around the grave site. I think Jim knew that I needed this time just as much as William and Helene. We finally said our goodbyes, and I promised to return. On the drive back home, Jim and I both agreed to do further research before sharing this news with the rest of the world. We knew that this was going to be a hefty claim to announce, and one does not try to reverse a guilty verdict before having facts to prove it, even if it did happen more than one hundred years ago. We needed to have proof to back this statement up. Newspapers back then were known to sometimes be inaccurate. I was going to need far more substantial proof, and I knew I had a huge task ahead.

That night, Jim and I were both exhausted from the lack of sleep the night before. We fell asleep faster than a kitten after a tummy full of warm milk. Within hours of falling asleep, I had another intense dream. This dream was so vivid I still remember it clearly. In my dream, it was nighttime, and I was standing on a street corner watching a large group of men in the distance. They were gathered outside a building and were closely huddled together. They were speaking loudly to one another, as if they were upset with something. As I walked closer, I could sense that the men were extremely agitated. A soft flickering light was coming through the window they were standing by, so I walked over to it. I walked right through the crowd as if invisible. As I looked inside, I could see a small man sitting in the corner, cold and frightened. I felt sorry for the man. When I turned to see what the men were upset about, I woke up. This dream was so intense that I jotted it down in my diary of dreams I keep. That morning, I shared it with Jim. He felt that someone might be trying to tell me something, and I agreed. This dream would later become a recurring vision for many nights, and each time additional details would be revealed.

That afternoon, we went to Seguin to check on the hotel. As we walked inside, the first thing I did was call for Emma, hoping that she was there. I wanted her to know what I had discovered and feel her reaction. I called and called, but we received no visit that day. This wasn't unusual, since she didn't come on a regular basis—just when she felt like visiting—but I thought it odd she wasn't here today. She must know that I uncovered the truth about William's innocence. I thought she would be glad I knew the truth and would come forward today. Then it hit me: it had been her father, Julius, who shot William dead in his cell. If William had not murdered Emma, then Julius was guilty of killing an innocent man. He was guilty of murdering a good friend. He had even been a witness at Helene's and William's wedding. I walked around the hotel telling her that it would be all right and that we would get this all straightened out. But she still didn't show.

As the days passed, I continued doing further research online for whatever I could find to help verify what we had discovered. I went through every available source out there, but nothing really substantially backed up the statement. What I did find interesting is that no one refuted the newspaper's statement claiming William's innocence. During the entire period from the death of Emma up to the death of William, everyone had an opinion and used the newspaper to express them. Now, everyone was silent after this claim of Faust's innocence. Then I wondered if, by some slim chance, the courthouse might have records of his murder trial. I felt that it couldn't hurt

Marriage License – Wilhelm Faust and Helene Rhodius

Emma's father, Dr. Julius Voelcker, was a witness to their marriage.

William Faust and Helene Rhodius's marriage license. *Marriage Records, Guadalupe County.*

to try, so I headed down to the county and inquired about records dating back to 1874. To my amazement, they had them. After requesting copies of the trial, they returned with a massive amount of papers. The mound of papers stood at least five inches high. It was a surreal feeling once the documents were placed in my hands. I was holding the entire accounts of the event that changed the path of our life's journey. I knew now that I would hear the truth as told by the people who went through this horrible experience. As I read the first page, I was instantly transported back to 1874. It was like watching an old black-and-white movie, and I was an observer just sitting in the background.

UNRAVELING A WRONG

The crime had been committed on July 23, 1874, around 1:00 a.m., but Emma didn't pass away until 9:00 a.m. That poor dear child had to endure eight hours of suffering. After her death, Sheriff Charles Sauer began deputizing volunteers to assist in the manhunt of tracking down suspects. Within a few days after her death, they had arrested numerous discreditable men under suspicion. These suspects were regular nuisances often in trouble with the law, such as town drunks and street beggars. They were quickly released due to viable alibis. It wasn't until nearly four weeks later that the sheriff finally began interviewing all those touched by the pain of this crime under the act of coroner's jury.

He started with Helene Faust, who brought up her suspicion of a traveling salesman, Martin Hessler, who made her feel very uncomfortable a week before the event. He came to her home trying to sell books, but her husband, William, declined his offer. He actually returned later, making Helene uneasy. Helene also stated that a "scruffy looking middle sized man with a light red mustache was seen looking in her window after her husband had left for Seguin the day of the crime." She had seen him standing in front of her fence and then again across from the Voelcker Drugstore in the evening. She felt that he was almost stalking her. Even the well-respected citizen Mrs. Landa agreed with that statement, for she saw the man also.

Then her mother, Johanna Rhodius, was interviewed. She stated that a man named John Kincade had courted Helene for many years. Once Helene declined his offer of marriage, he vowed to "revenge her refusal on her and

Statement of Helene's stalker. *Criminal Case Record, Guadalupe County.*

her family." Johanna said that the entire family feared him. A relative of hers named August Berger even witnessed Kincade's threat on them.

August Berger also gave a statement of his suspicion of a light-skinned African American woman who had been freed after the war. The woman, named Sue Freeman, accused William Faust of being her child's father. According to her, Faust had promised that once the child was born, he would support the child and she would live like a lady. When he refused to acknowledge her or the child, she vowed to make him and his wife suffer the consequences. Burger felt that it was someone connected to her who had committed the crime out of revenge. Faust denied being the child's father profusely, stating he had never seen this woman ever before.

Then Emma's brother, Emil Voelcker, was interviewed. He was the only actual eyewitness to the crime. As he gave his account of what he had seen that night, it was painful to read:

> *I heard some noise between 1:00–2:00 am made by Mrs. Faust* [Helene].
> *As I entered the room I saw a man standing in the door just in the act of striking my sister. I told the man to leave and the man left immediately. My sister was struck last, my sister was asleep and Mrs. Faust had already*

Statement accusing John Kincade.
Criminal Case Record, Guadalupe County.

been struck. The man had a brown shirt, dark pants and appeared to be barefooted, the man was slender built & about 5 feet 4 inches high. I saw the instrument in the man's hand, with which he struck Emma & Mrs. Faust. It appeared to be an ax or a club. I believe it was a white man because he had straight hair, there was a light in the room where my sister & Mrs. Faust were sleeping, and the wick was turned down low when they went to bed. When I saw the man the light was turned up. The man appeared to be about 23 years old, he moved too quick & easy for an old man. I am certain Mrs. Faust was struck first.

It must have been painful for a young fifteen-year-old boy to have witnessed such a horrible thing. My heart hurt so badly for the poor child.

Next was Dr. Julius Voelcker's account. He stated that he and his wife were sleeping eight or ten steps away from his daughter's bedroom. He was awakened by a cry from his son saying, "Papa! Come! There is a man in Mrs. Faust's room killing her!" He ran as fast as he could to where his daughter slept. When he entered her room, he saw his child bleeding badly from a wound to her head. She was laying on her right side, and the wound was on her left. He felt for a heartbeat, and she was still breathing. Then he turned

to look at Mrs. Faust, who kept saying, "I can't see! Take this away from my eyes." Blood was oozing from her head. Mrs. Voelcker entered the room and began screaming for help. He noticed three gold rings and a chest pin lying on the table.

Mrs. Voelcker's interview was rather intriguing to me:

> *I woke up that night from a crack I heard and afterward the slamming of drawers as if somebody was opening them very carefully. I sat up and could not hear anything more. I thought there might be a thief in the drugstore. I kept listening for a little while, looked at my husband who was asleep in a bed close by. I thought thieves but that [illegible] would find nothing in the drugstore but medicines. I'm as certain as I can be that I heard the noise of the drawers. The head of my bed stands against the closed door. There is a thin partition hardly 6 inches distant. I opened the drawer several days later when it cracked the crack that was the same or that which woke me up in the night.*

Mrs. Voelcker's statement about hearing the thieves. *Criminal Case Record, Guadalupe County.*

Statement proving evidence of attempted robbery. *Criminal Case Record, Guadalupe County.*

In Julius Voelcker's statement, he said, "Mr. Floege asked me if I knew if there was any money in the drugstore. I told him, he knew very well that I take all of the money out in the drawer except the small change and afterward my son Bruno was sent in the drugstore, came back at once and said there are three drawers pulled open."

In the interview with the then owner of the Magnolia Hotel, Rollin Johnston, he stated that "William Faust was given a room at the hotel on the night of the murder. Johnston walked him to his room sometime after midnight. Faust shared room #3 of the original portion of the hotel with another."

After these brief accounts, the sheriff began pursuing any possible leads. They searched homes and surrounding areas for any possible clues, such as clothing matching Emil's description of what the murderer had been wearing. They brought in numerous men who fit the features of the murderer, making these suspects scramble to provide concrete alibies. The search was carelessly handled and didn't last but a few days. It all came to a halt once the massive gossip began to swell.

One rumor was started by Mr. B. Burger, who shared the story of how the Rhodius family received a letter from Germany announcing that they were about to inherit $9,000 from a family estate. He thought it suspicious that Helene and William had been dating for a year and engaged for a month and then they marry right after the family received the letter.

Statement of Johnston, who walked Faust to the room. *Criminal Case Record, Guadalupe County.*

The worst spreader of pure gossip was a woman named Barbara Muller. She stated that Faust had told Helene she was only allowed to stay at the Voelckers' home and no one else's. According to Muller, Helene said that the man who struck her had hands soft like her husband's. She also accused Faust of owning an axe before the murder but his axe was missing after. Her nastiest rumor was that Faust was being rough on Helene when he cared for her after the attack.

The most damaging report came from a man named Isam Taylor. He was labeled by many as a man who could not be trusted because he craved attention and notoriety. Taylor stated that on the night of the crime, around 2:00 a.m., he saw a man racing past his house on a horse with great speed. Although the rider was wearing a hat and turned his head away so as to not be seen, and though the sky was pitch black, he identified the rider to be Faust. He also stated that the horse he was riding belonged to Rollin Johnston, owner of the Magnolia Hotel. Now with no substantial suspects in custody, the blame was turning toward Helene's husband, William Faust.

With tensions strong and emotions high, all demanded justice for Emma. The sheriff knew that the town desperately wanted an arrest. So he stopped looking for other suspects and focused solely on Faust. With nothing but rumors pointing toward Faust, Julius Voelcker officially accused Faust of

murdering his daughter on October 31, 1874, in a sworn statement. Faust was arrested that very same day and placed in the New Braunfels Jail. With nothing more than hearsay, Faust remained in jail for nearly two weeks before being released under the writ of habeas corpus.

During the time of Faust's release, the prosecutor for the state, John Ireland, and the defendants, W.E. Goodrich, W.M. Rust and Douglass, began to build their cases on Faust's behalf. For a full month, people were subpoenaed to give their personal accounts on July 23 along with their personal opinions of Faust's character. They were also asked about Isam Taylor's character, regarding whether he could be trusted to tell the truth.

Most of the witnesses were from New Braunfels, but only a handful were from Seguin. The people from New Braunfels had already made their decision that Faust was guilty from the ugly rumors that had been circulated. Plus he was known for being a person who showed little emotions, so he was considered heartless in their eyes. Faust was also trying to obtain information to help prove his innocence. Because he had to remain home to care for his wife's injury, he hired a private detective, Mr. Lyons, hoping to clear his name and track down the real murderer.

By November 17, seventy-two witnesses had been brought in to testify. Unbelievably, each witness was paid $100 to testify. Back in the late 1800s, this would most likely be about a month's salary. I would imagine that everyone was more than willing to be a witness at that amount paid, whether they knew anything or not. These numerous witnesses cost the State of Texas more than $7,000. That was a great deal of money back then, and this didn't even include all of the other fees, such as from lawyers, clerks, Western Union messages sent back and forth and so on.

By now, Faust was painfully aware that the state was making a direct case against him and no longer searching for other suspects. He knew that it was just a matter of time before they came with a warrant to officially arrest him. All this time, he was at his mother-in-law's house in Selma tending to Helene. He received a postcard from a friend, Mr. Wippercht, who told him to come to Seguin for safety, as he had numerous friends who believed he was innocent. When Faust read the postcard, he began to cry. His friends in Seguin were willing to help prove his innocence and see that he got his trial moved out of New Braunfels. He said his goodbyes to Helene; she begged him to take her along, but he refused. It was not safe for her, and she needed to stay with her family. He kissed her forehead and then turned to his sister-in-law, Alwina (aka Irene). He asked her if she believed in his innocence, and she nodded yes and began to cry too. Then he went up to his brother-

Witnesses examined. *Criminal Case Record, Guadalupe County.*

law-law, Edward, whom he loved as a brother, and asked him to go get their horse. Then, surprisingly, his mother-in-law yelled, "No, do not do anything for him. I do not want a murderer in my house any longer!" She told Faust that she now believed he was guilty, too, and refused to allow their horse to be ridden by a murderer. His replied, "Oh Ma, how can you say such a thing?" and then left in tears. According to Faust, he was crushed by her statement. He had grown to think of the Rhodiuses as his own family.

Once he reached Seguin, he went to the home of Mr. Dietz, where he was confronted by two deputies, who stated that he was under arrest even though they had no legal warrant. His friends in Seguin refused to turn him over without legal authorization, but Faust, not wanting trouble, volunteered to turn himself in. In his heart, he knew that he was innocent and felt that the courts would eventually come to that conclusion too. He was then taken to the jail in San Antonio to avoid possible lynch mobs, which were rampant in Texas.

Faust would remain in jail for many months as the state continued to prepare for the trial. His lawyers tried desperately to move the trial to a

city other than New Braunfels, but the judge declined. All of the jury men personally selected by the prosecutors knew Dr. Julius Voelcker and his daughter, Emma. The defendants were well aware that an impartial jury would be out of the question, but their legal hands were tied. There was nothing they could do.

THE TRIAL

It was late fall 1875, more than a year since the murder. During this time, the law had already made the decision that Faust was guilty. With nothing more than hearsay, law enforcement officials had stopped looking for any other possible suspects and focused on building a case against Faust. They were allowing him to sit in jail as long as they wanted. In the minds of many, he was "guilty until proven innocent." Numerous character witnesses against Faust were being collected, along with local residents as jury members. The prosecutors required sixty jurors to be on standby for the case, and all were citizens of New Braunfels.

The defense lawyers for Faust were Douglass, Goodrich and Rust and were hit by resistance at every corner while requesting proper legal treatment toward their client. They fought to get Faust moved out of the Bexar County Jail, where he was being mistreated, but were refused several times. They had to request a new judge because the one chosen by the state had actually worked with the prosecutors on the initial case against Faust. They fought relentlessly to move the trial to another city but were refused. When the defendants discovered that the man who shared a room with Faust at the Magnolia Hotel had never been questioned, they scrambled to locate him. Once they did, he was in St. Louis, Missouri, and unable to return to Texas. They had to correspond with him by mail, which took weeks. By then, with so much time passing, the man could not remember anything about that night or what his roommate even looked like.

They were frustrated when they discovered that Mr. Lyons, the private detective whom Faust had hired to help find the real killer, had been secretly working against him the entire time. He was essentially going around planting the seed in everyone's head that Faust was indeed the murderer. Not once did he search for another suspect. The governor of the state of Texas, Richard Coke, sent a warning to all those involved in the case that the costs were getting out of hand. Governor Coke was up for reelection, and this massive cost would look bad during his campaign. He demanded that this case finally be brought to a close and quickly. With that mandate, the trial was set to proceed immediately. With such short notice, this left the defense in a rush and unprepared. One by one, day after day, witnesses were brought in to state their personal opinions of Faust's character and why they believed he was the killer. This is something that is unheard of in this day and age of court proceedings. Some of their motives for Faust's guilt were unreasonable, unsubstantiated, hypothetical or flat-out absurd:

Accusation: Although he was dating Helene for more than a year before getting engaged, they married just one month after Faust heard of the Rhodius family's $9,000 inheritance. He was simply chasing the money and wanted his wife dead so he could inherit the money all for himself.

In Defense: This inheritance had not even been verified yet; it was only a possibility. Plus the money was going to the entire family, not just Helene. That meant $9,000 would be split eight ways, including Helene, which was not that much anyway.

Accusation: Faust had another wife and two children. He wanted to kill Helene to go back to his first wife.

In Defense: This is completely untrue and just a rumor. He was never married before and had no legal children. There was only the accusation from an unmarried woman whom no one believed. She was never subpoenaed to testify either.

Accusation: Mrs. Voelcker stated that she knew of no one else who would harm the family.

In Defense: Mrs. Voelcker stated that she was awakened that night by someone going through the drawers of the drugstore. The headboard of her bed butted up against the thin six-inch wall between her bedroom and the drugstore, making it easy to hear. The next morning, they found drawers open and receipts tossed about as if broken into. Oddly enough, there were two other stores broken into the same night of the murder, but no one connected the dots. The robber probably got discouraged that there was no money and then headed behind the drugstore, where he saw Helene's light on; he may even have been watching her earlier that day. He probably spied through the open curtain, saw her jewelry on the table and thought it an easy robbery. He entered through the opened door and reached for the jewelry but Helene heard him. She sat up, and the robber struck her before she could see him. Then Emma probably began to sit up, so he struck her on the left side of her head. There is no way the injury caused on the lower left side of her face could have been done while still lying down. The force even caused her to fall on her right side.

Accusation: Since Helene's two little dogs did not bark when the murderer entered the room, the dogs must have known the attacker.

In Defense: The entire time after the attack, with dozens of excited, distraught people and lawmen running in and out of the bedroom, it is stated that the dogs did not bark then either. To say they would only remain quiet for Faust was an assumption, not a fact.

Accusation: Faust did not look at Emma when he was brought into the room where she and Helene were after the crime. This proves that he was heartless enough to kill her.

In Defense: Faust was pulled aside by friends when he arrived before entering the room to prepare him to see the two ladies' injuries so that he would not go into shock. He was told that Emma's head injury was horrific. He covered his eyes and avoided Emma's face because he loved her and could not handle seeing her that way. Seeing his own wife in such condition was enough to make him drop to his knees in tears.

Statement of Faust,
who was warned about
Emma's appearance.
*Criminal Case Record,
Guadalupe County.*

Accusation: Faust didn't go looking for a suspect after his wife had been badly attacked nor offered a reward.

In Defense: How could he search? He was caring for his badly injured and now blinded wife whom he loved. He had very little money but did hire a private detective for twenty-five dollars to search for him.

Accusation: Faust changed his clothes before arriving to New Braunfels and then tossed them before returning to the Magnolia Hotel.

In Defense: He only had a small bag when he checked in, carrying pharmacy papers and only that bag when he left too. Where did he supposedly get the clothes that were never found?

Accusation: Faust was strong enough and highly capable of stealing an axe and using force to chop both women's skulls.

In Defense: Faust was a chemist and pharmacist who was rather small in stature. He never chopped wood because his hands were needed in his occupation to compound drugs. He always hired a man to chop their wood and asked his brother-in-law to do any manual labor needed, which is why his hands were so soft. Also why murder his wife in such a heinous way with an axe when he could have simply poisoned her in numerous ways back then and not get caught?

Statement of the detective who betrayed Faust. *Criminal Case Record, Guadalupe County.*

Accusation: Faust presumably snuck out of a room while another man was sharing it, caught a spirited young horse that would only allow one person to catch it in the locked stable across from the Magnolia Hotel, saddled it and galloped off at fast speed without a peep.

In Defense: Faust almost always rode by wagon when traveling back and forth to towns. He would make arrangements the day before when he needed to travel from town to town. He was known as a frequent hitchhiker of a sort. In the rare times he did ride by horse, he needed someone to accompany him because he was not familiar with the trails, and he would ask someone else to catch and saddle the horse used. The hotel was completely full the night of the crime. Someone definitely would have heard him trying to catch the horse, saddle it, ride off in a gallop and then return the same way, put the horse back in the stable, unsaddle it and run back to his room.

Accusation: Numerous people stated they heard the rider and horse coming from New Braunfels to Seguin at a high gallop.

In Defense: With so many people being awake at 2:00 a.m. and hearing the horses gallop by from New Braunfels to Seguin, why did they not hear the horse galloping by from Seguin to New Braunfels? The murderer must have already been in New Braunfels, committed a botched robbery, killed Emma and attempted to kill Helene to keep them silent, got on his horse and rode to Seguin to escape being caught.

Accusation: An axe was found in the river with what appeared to be remnants of hair and dark spots deemed to be dried blood. It was examined by Dr. Voelcker, who identified the hair as Helene's eyebrow hair.

In Defense: First off, allowing the distraught father of the murdered child to be the legal examiner of the possible instrument used in the crime is absurd. That axe was a communal tool used by everyone in town and used for chopping up wild game too. The axe was not even proven to be the actual instrument, only assumed because it was found in a river several months after the crime. They had no actual proof that Faust even touched that axe.

Statement from Bruno Voelcker stating that they examined the axe. *Criminal Case Record, Guadalupe County.*

Accusation: The prosecutors felt that Faust was guilty even though they had numerous eyewitnesses seeing him go to bed at the Magnolia Hotel around 12:30 a.m. (The murder was committed between 1:00 a.m. and 2:00 a.m.) Their scenario was as follows: Faust entered his room at the hotel, where there was another man sharing it. Thirty minutes later, he gets up, walks out the door without disturbing the roommate, walks from the back of the Magnolia Hotel to the front office, breaks into the Magnolia Hotel's office, gets the keys to the stable across the street, unlocks the gate and then goes back to the office to return the keys. He then catches the feistiest horse there, saddles it and rides in a fast gallop to New Braunfels without anyone seeing or hearing him. Somewhere along the way, he changes his clothes before arriving in New Braunfels. He then stops at the Voelcker Drugstore to make it appear that it was broken into by pulling out drawers and tossing receipts. Then he walks around the drugstore, enters Emma's bedroom door and then strikes Helene and kills Emma. Then he runs to his horse, gallops back to Seguin, changes his clothes again and discards them, puts the horse back in the stable, unsaddles it and then runs back to his hotel room—and no one saw or heard a thing. He accomplishes all of this in one hour.

In Defense: Ridiculous! The prosecutors called the timeframe worthless to the case, but this is impossible to accomplish in one hour, plus no one heard the horse when it galloped from Seguin to New Braunfels. That's because the murderer was already in New Braunfels. Just the round-trip ride to and from the two towns was a total of two hours.

Accusation: While Faust was sitting in jail, a boy named Arnold accused him of murdering his uncle in 1867. Faust was now considered a multiple killer.

In Defense: This was a case of mistaken identity. No one knew it, but William Faust had a brother named Edward Faust, who looked very much like him. Edward had been a deputy sheriff in DeWitt County for many years but was killed in 1869 while trying to arrest a man for murder. He was known for being a tough lawmen and shot many men. This boy's uncle was one of those unfortunate men. William had told the Rhodius family of his brother when Edward was killed.

Edward Faust's obituary from the *Officer Down* records:

Deputy Sheriff Edward Faust, with a posse that included Henry Gonzalvo Woods, and others, went to the homestead of John Kerlick in DeWitt County, near Yorktown. The posse was sent there to arrest Christopher Kerlick for the stabbing death of Thomas Lockhart in Harris County, which had occurred on September 24, 1869. When the posse reached the homestead, they were told the wanted person was not there. There are several different accounts as to what started the shooting, but the newspaper accounts stated the posse searched the house and as they were leaving, they were fired upon. The shooting left Deputy Sheriff Edward Faust and posse man Henry Woods dead and at least one other person wounded.

The next day the Sheriff, with a posse, went back to the Kerlick house and arrested Christopher and William F Kerlick, and started back to Clinton under guard. The two young men allegedly tried to escape, and were shot by the guard and both killed. The ironic twist is that Christopher Kerlick was no-billed by the Harris County Grand Jury two days before shooting, but this information was unknown to the lawmen. This communication failure cost the lives of 4 men. Edward Faust was reported to have been 30 years old and a native of Germany. His place of burial has not been located. It is unknown if he had any surviving family members. Henry Woods was 53 years of age and a former Captain in the Confederate Army. He was survived by his wife. He is buried in the Woods Cemetery in Yorktown, Dewitt County.

On October 15, 1875, the trial finally came to an end. The members of the jury returned to the courtroom, and the foreman, Frank Nowotny, read their decision. The verdict was "guilty of murder." As I read the copy of the verdict, my heart sank. How hard it must have been on William and Helene to hear those words. Here they had only been married a little over a year, and now their time together was over.

For the next few months, Faust's attorneys fought to have a new trial scheduled because of the unfairness of his hearing. They listed numerous sustainable reasons and presented them to the judge. Their requests were ignored time after time. They were even preparing to bring it all the way to the Texas Supreme Court. His attorneys felt that he had a good chance if they could just arrange for another trial in a different county. Faust was sentenced to life in prison instead of death by hanging, which would at least keep him alive until a new trial could be set. According to the newspapers,

Statement of the guilty verdict. *Criminal Case Record, Guadalupe County.*

this life sentence enraged the citizens of New Braunfels. After a year of seeking justice for Emma, hearing that Faust was not to be hanged made their anger grow to a volatile state. These citizens were ready to put this pain behind them—they wanted a hanging. It is said that Faust had to be moved to several different locations just to avoid a lynch mob. Then, to make things worse, during Faust's imprisonment a new rumor began to swirl causing even more anxiety.

A woman had come forward stating that a man named M.P. (or M.E.) Deavors, whom she was caring for at her home in Bandera County, confessed to the crime of murdering young Emma and mutilating Helene. The possibility that this new evidence might help Faust get a new trial or worse, freedom, infuriated the community.

Law enforcement officers continued to move Faust from jail to jail for protection, but oddly enough, on a hot summer evening, they moved him to the Comal County Courthouse basement, located across the street from where Emma had been murdered. Then, in the early hours of the morning, with nearly forty men guarding the courthouse, someone was still capable of sticking a gun through the barred window and shooting Faust dead. On July 28, 1876, William Faust was officially pronounced dead, and the attacker was listed as unknown. Strangely, Faust's murderer was never even sought after that. Helene, who had always vouched for her husband's innocence, had him buried in her family's cemetery near her own father. Numerous newspapers across Texas described the mob scene as a horrible injustice. One editor wrote, "The harm done to the community by a mob murder

[*Special Telegram to the Galveston News.*]

NEW BRAUNFELS, July 31, 1876.

William Faust, the murderer of Miss Emma Voelcker, was shot dead Saturday night through the window of the court-house by an unknown person in the presence of forty men as a guard. The avenger of Miss Emma Voelcker made good his escape. However consummate and sweet the revenge to the perpetrator, thinking people consider that he has robbed the law and society of their revenge, and is, in a legal sense, guilty of assassination. The incident is regarded as another example of the inefficiency of the courts in the regular enforcement of the law.

Article stating that Faust was murdered, from the August 1, 1876 *Galveston Daily News.*

is greater than by the original murder, for the mob murder breaks down all confidence in the officers of the law at once, the other murder does not."

After many weeks, I finished reading the entire court proceedings and newspaper articles and taking notes. Throughout this entire experience, I had become consumed with this case. Every morning, I raced to the stack of documents to read them over my morning coffee, and at night, it was my last thought before falling asleep. I had many intense dreams throughout this process, but none compared to the dream I had the night after reading about the killing of William Faust.

Once I fell asleep, I began dreaming. In my vision, I found myself on a dark street corner. I could see men all gathered outside a brick building. A window was in front of them, with a faint light shining. The men were all yelling, mumbling and waving their hands in angry gestures. After reaching the building, I could move back and forth through the building's walls. I went through the exterior wall and into the room with the dim light on. There was a terrified man cowering in the corner of the room, and he kept saying, "Please don't do this my friend. Please don't do this. You will only regret it. I did not kill her." In my heart, I knew it was William Faust. I turned to see whom Faust was pleading to and then walked through the wall once again. Now on the outside, I could see a man crying as he gripped a gun with both hands. I knew this was Julius Voelcker. He was so distraught. It was obvious that he had never held a gun before, for his hands were shaking badly. Then, I turned to see the faces of the angry men surrounding him. They were all aggressively yelling, "Do it Doc! Finish him off Mayor! He deserves this! If you don't, we will! Do it for Emma!" Then Julius closed his eyes and pulled the trigger, and the gun went off. There was a puff of smoke streaming over Dr. Voelcker's face, and the crowd quickly grew silent. You could almost hear a pin drop at this point. I looked back at William in his cell, and he was slumped over in the corner, bleeding. Even though it was a dream, my heart hurt for this man. I looked back outside at the crowd, and Dr. Voelcker's head was hanging downward and his body grew limp. He gently released the gun, and it slowly dropped by his side. The crowd of men gradually began

to disperse one by one. Some were patting Dr. Voelcker's shoulder before leaving, saying, "It's over, my friend." After a few minutes, Julius fell to the ground and softly wept from exhaustion.

When I woke up, I just lay there quiet in my bed. I felt overwhelmingly sad for both men. The town's need for instant justice, pressure from the governor and the intense grief of a loving father had caused an innocent man to be killed at the hands of a decent man. I began to think of all the people who would have been affected by this senseless assassination. The men who believed in Faust's innocence lost a good friend, Helene lost her sweetheart and the Rhodius family would forever be labeled the family who loved a murderer. Dr. Voelcker, who spent his life helping others by being a pharmacist, would regret killing another human being. This entire unfortunate episode, from the murder of Emma and mutilation of Helene to the assassination of Faust, was truly a tragedy.

SAYING GOODBYE

The next morning, I drove over to the Magnolia Hotel for some quiet solitude to absorb everything. I sat in the children's room, where I felt closest to Emma. I spoke out loud, hoping she would show up to hear my words. I said, "I understand everything now, sweet Emma. I fully understand this journey you had sent us on. From first being introduced to your tragic story by a stranger in the library, guiding me to the German museum library, then to leading us to save the Magnolia Hotel to reveal the truth, I get it now." I told her that I knew William was innocent and that the murderer was M. Deavors. I told her I knew Deavors had confessed again right before he passed away because he wanted to cleanse his soul before meeting his maker.

According to his confession, Deavors had been a traveling music teacher and taught vocal music. He had been staying at the Magnolia Hotel in the second-floor room no. 3. He most likely overheard Faust speak of the wealthy Voelckers and how his wife was staying at their home. Deavors rode to New Braunfels from Seguin that night with the intention of robbing several stores along with the Voelcker Drugstore. When he broke into the drugstore, all he discovered were a few receipts and no money in the cash drawer. He then went to the back of the drugstore, where the Voelckers' home was, and intended to rob their home. He went past Dr. and Mrs. Voelcker's bedroom, where he saw a light on. The back door was open to Emma's room because of the intense summer heat.

As he walked into their room, Helene heard him. When she sat up, he slashed at her eyes with an axe. Helene screamed out in fear, "William, he's killing me," and grabbed Deavors's hand. His hands were soft because he was a music teacher, not a laborer. Helene heard Deavors respond, "William's not here. He is in Seguin." He then turned to Emma in fear of being identified and struck her head. There was no time to grab Helene's jewelry, which was sitting on her nightstand, because Emil suddenly walked in. When Emil screamed, "Get out!" Deavor got on his horse and took off fast. He rode toward Seguin from New Braunfels, as several people heard the horse but never actually saw who the man was. No one heard or saw him ride to New Braunfels because no one was paying close attention at that time. Why would they? No one knew that a murder was going to take place that evening. He probably casually rode to New Braunfels without a concern in the world. I then told Emma, "I know the truth now, sweetheart. It was Deavors, not Faust." Then the children's room filled with a fragrance of baby powder, and the feeling of the room grew jubilant. I knew it was Emma.

I looked up at the doorway, and there she was with the biggest smile on her face. She didn't say a word; she simply giggled. She then spun around and started to skip down the hallway toward the front entrance as if she wanted me to follow. I thought it odd she didn't stay with me longer, so I jumped up to see where she was going. As I watched her happily skip toward the front entrance, I wondered what she was up to. As I made my way through the sewing room (also the gift shop), I saw Emma stop at the front door and turn toward me. She was smiling so sweetly. Then, before I reached the foyer, I stopped in my tracks. The atmosphere grew so intense it startled me. All I could do was raise my hand over my mouth in astonishment. Honestly, I was so overwhelmed by the feeling I didn't know how to handle it. Emma had stopped in front of the entrance and was reaching her hand upward. I forced myself to step closer to see what she was reaching for and took a few footsteps forward. I nearly fainted by what I saw. It startled me so badly that I looked away and then propped myself against the wall. Was I really seeing what I was looking at?

After a few seconds, I regained my composure and moved toward Emma slowly. When I did, I could see the ghostly feature of a man gently taking Emma's hand in his. I was so petrified by this encounter. Although his face was undistinguishable, I could tell he was wearing a long coat and hat. By his side was a shadowy figure of a female with her arm draped around his. She wore a long flowing dress and a shawl around her shoulders. After Emma

took the man's hand in hers, she looked up at him with such fondness. Then she turned toward me with the biggest smile. As I stood there, unable to move an inch, I knew this couple was Helene and William Faust. Suddenly, I was no longer afraid. Then they both turned their attention to me, and my heart began to pound hard in my chest.

As they stood there in the foyer of the hotel looking at me, the room became calm and peaceful. Their physical features grew clearer, and I struggled not to cry. The couple whose past lives changed the course of so many were now standing in our foyer. Not knowing how long their presence would last, I quickly observed every detail of their appearance. William's attire was that of a man dressed for church in his lengthy woolen coat and brim hat. His shirt was neatly pressed, with an ascot to spruce up his outfit. Helene looked so graceful, outfitted in a flowing lacelike gown and a delicate shawl. I noticed a necklace dangling from her neck with a charm that appeared to be a bird in flight. The couple was beautiful standing there together. William raised his hand to reach his hat rim and then tipped his head in a slow nodding gesture. Then Helene smiled as she gently curtsied in her long flowing gown. All I could do was smile and slowly nod my head in a yes response. Once the reality set in that the spirits of William and Helene were actually standing right in front of me, I began to wonder why. Then it hit me. After nearly 150 years, William's good name was finally going to be cleared. The stigma of being a child murderer was about to come to an end.

The couple reached down to give Emma a hug, and William kissed her forehead. Then they slowly turned toward the door and vanished. Emma looked up at me and began giggling as she slowly twirled like a tiny ballerina in a music box. As I watched Emma dance in front of me, I told her how proud I was of her. She walked toward me and put her arms around my legs in a hug. The feeling was something I sincerely have a hard time explaining. The warmth and kindness from her hug was simply beautiful. When she released her hug, I asked, "Will you still visit me?" Then, in her usual precious manner, she smiled and gradually disappeared. My legs began to give way. I leaned up against the wall and then slid down to rest on the floor.

I sat there trying to comprehend all that had just happened. What an amazing child Emma was. Her descendants would most definitely be incredibly proud of their unwavering ancestor. This girl had accomplished what she had set out to achieve in clearing the name of an innocent man. She even aided in helping the world to understand the emotionally charged mistake her grieving father had made. It all made sense to me now. I fully understood why the Magnolia Hotel had so many spirits that wished to

communicate with us. These unbelievably resilient spirits wanted to right a wrong, and they quietly waited for just the right person to come along to help them.

The owner of the Magnolia Hotel in 1874 was T. Rollin Johnston, who had been a close friend to Faust. T. Rollin's mother was Captain Hays's sister-in-law. Hays was my ancestor Big Foot Wallace's closest friend. T. Rollin's office was located in the front far-right corner of the hotel, where most of the footsteps have been heard. The hotel's stable was located across the street, where Jim and I often hear the neigh and whinny of horses during the night. There indeed was a bar inside the hotel right where we smell cigar smoke and hear the clinking of glass mugs. Our whistling spirit, Sam, resides upstairs and was a witness for the defense on behalf of William's case. The prosecutor for the state was Governor John Ireland, whose daughter, Matilda, and son-in-law, Evan, ran the Magnolia Hotel for years. He resigned as the prosecutor before it came to trial. Ireland had been my hero in my youth. I sincerely doubt this was a coincidence.

The most profound discovery was that Faust had, in fact, slept in the original 1846 three-room Magnolia on the night of the murder. Although it was in the middle of the building, they called it room no. 3. This area is in the back, where the adobe section is, and is now our private residence. His room was located where our kitchen is now. Jim and I have had numerous paranormal accounts in there. Now we know that the spirit causing all these accounts was William Faust just waiting for us to figure it out.

We have always called the female spirit who also resides in the adobe "Miss F." We labeled her that after a session with the dowsing rods. We went down the alphabet asking what her name began with. It always noted "yes" when we reached the letter F. In the trial records, Helene Faust was referred to as "Miss F."

So, who is in room no. 3, located in the corner upstairs, that we call the murderer's room? This spirit was always a mystery to me. He never offered any communication; he would only make his presence known by his energy. Although I assumed it was Faust, I never felt completely comfortable stating that. Often I would change the name of the room from Faust's room to simply the murderer's room. Many times when entering that room, the atmosphere would grow heavy and uneasy. The spirit would cause intense heat in the room and abruptly move things such as a chair. When this spirit comes forward, he appears as a dark red aura, which has even been captured in a photograph. Often the windup clock in that room (which does not work) would chime during the time the crime was

Map of original Magnolia Hotel, drawn by T. Rollin Johnston. *Criminal Case Record,*
Guadalupe County.

committed between 1:00 a.m. and 2:00 a.m. I now know that this spirit is
Mr. Deavors, the actual murderer.

I'm confident that Deavors had stayed at the Magnolia Hotel that
dreadful evening in room no. 3. He must have overheard Faust saying that
his wife, Helene, was sleeping over in New Braunfels with the Voelckers.
According to the documents, many others heard Faust speak of that
openly. Thinking that this would be an easy robbery, Deavors headed
to New Braunfels, unnoticed by others. Once there, he scouted out the
Voelcker Drugstore and their home located in the back of the building, as
well as other businesses nearby.

He was seen by Helene and even Mrs. Landa, but no one paid attention
to their suspicions. As stated in the records, Helene screamed out for her
William. Then her attacker said, "William is not here. He is in Seguin."
This is proof that Deavors knew exactly where Faust was. After his botched
robbery and attack on Emma and Helene, he raced back toward Seguin.
He probably left his horse in another stable and then crawled back into his
bed in room no. 3. Law enforcement officers never even interviewed the
guests who were staying at the hotel that night, and it was at full capacity.
Deavors probably casually rode out of town the next day, knowing that
he had gotten away with murder. Then his conscience or the fear of God

Map of Emma's home, drawn by Emil Voelcker. *Criminal Case Record, Guadalupe County.*

caused him to confess before dying; the truth was revealed, but no one listened. By the time anyone acknowledged his confession, Faust had already been killed.

After uncovering the truth about Deavors's guilt, we wondered if he would finally vacate room no. 3. I avoided the room for a few days and then decided to see if there was any evidence of his continued presence. Not knowing what to expect, Jim came along with me. I felt that it was important to let Deavors know we had uncovered the truth of his guilt. As we entered the room, it didn't seem to be anything out of the norm. It still had that usual heavy, gloomy atmosphere about it, but no presence yet. Then I spoke out loud and said, "We know the truth now, Mr. Deavors. We know it was you who killed Emma, blinded Helene and caused a painfully grieving father to wrongfully execute William Faust, who was innocent. Your cold, heartless act damaged the lives of so many. The truth is out now." Jim and I really didn't know what to expect once we confronted Deavors of his guilt. We were certainly not prepared for what happened next. Suddenly the room got extremely cold; it was chilling to the bone. There was a gust of wind, and the room filled with an intense feeling of

rage. Jim grabbed my arm to pull us both backward to exit the room. Then there was a red ghostly mass standing right in front of us. There were no visible features, just a thin, shadowy, ominous red form looming in front of us. I calmly said, "We are not afraid of you, and the truth of your guilt will be shared with the world. You may continue to reside here in peace, as I know you are bound, but we will never fear your presence, so don't even bother." Then the mass slowly began to fade away, and the room grew calmer. Jim and I were so shaken by this experience that we both stood there stunned for a moment. We turned to hug each other, and then Jim said, "I don't know about you but I could use a drink right about now." All I could do was nod my head and then turn to walk away.

Nearly a year has passed since Jim and I uncovered the truth of Emma's death and the innocence of Faust. As expected, the murderer Deavors continues to reside in room no. 3. He can still be seen peering out his window from time to time. Quite often on our guided tours, he comes forward, causing our guests to feel a bit uneasy but not threatened. Deavors does not communicate with us in any way, but we are well aware of his presence. We simply coexist with each other. We have no idea what the future holds for this lost soul—this is between him and his maker. All we know is that he still exists in that room, and we have accepted his presence.

We go to visit William and Helene's grave site often and can feel that they are finally at peace. Their grave site deserves to be cared for because they were innocent victims in a heinous crime. Although we thought that Emma would no longer visit us once the truth was discovered, she is still a frequent visitor. This amazing young spirit has even made us aware that the Magnolia Hotel has far more secrets that still need to be told, such as who the young female spirit is residing in our 1840 Indian raid shelter. After years of owning the hotel, this spirit has yet to communicate with me. She has recently become physical toward me by pushing, tripping and even pinching my back. This type of behavior is becoming more frequent, so I no longer enter without Jim by my side.

"Pink Rosebud" was a regular lodger at the Magnolia Hotel during its tenure as a house of ill repute. Then, one day, she mysteriously disappeared and was never heard from or seen again. We want to know what happened to her, and from her constant presence, we believe she wants us to know also. Even though she was a well-known prostitute with a lengthy record, she deserves the right to justice too.

Since I began writing this book, several new spirits have come forward seeking help. The second floor of the hotel has become somewhat unsettling. There is a new female spirit in the communal area, a male spirit in the prisoners' room, a young male outside the pink bathroom and an intense unknown energy in the hallway—all seeming to want their presences known. There are even spirits now coming forward outside the building. Passersby have seen shadow figures roaming about the property. One is often seen near the cement stump by the bell, one on the front porch and several walking along the sidewalk near the adobe. We believe they are thoughtfully guarding the building from uninvited guests.

Many of our spirits continue to reside at the hotel by personal choice, like Ranger Campbell, Miss Sarah, Miss Willie, Mrs. Read, little William, Jenny, Lil' John and Idella. We cherish their presences every time they come forward. As for the others needing assistance, we plan on doing everything we can to aid them. With our continued research, my ability to communicate with them and the aid of Miss Emma, we have a good chance of helping them. Now, every time I walk through the doors of this amazing old Magnolia Hotel, I can't help but wonder if this had been my destiny. Was I groomed by life to help rescue a dying building and redeem an innocent man? Or had I simply been selected by a young spirit because I showed the right qualifications? No matter the reason, I am grateful to have played a part in this fascinating journey. I feel blessed to have come across the story of a little traveling spirit named Emma who danced her way into my heart.

CONCLUSION

J im and I struggle with the massive expense of restoring one of Texas's historic landmarks. The Magnolia Hotel was supposed to be just a weekend hobby for us but is now a full-time rescue effort. There have been many days we thought we'd have to walk away due to the mounting expenditures. If it had not been for our active spirits and for the desire of guests hoping to experience their presence, we would not have gotten this far. In our hearts, we believe that the Magnolia spirits assisted in creating a way to help cover the enormous costs. Our Guided Ghost Tours sell out as soon as we announce them, and the reviews are wonderful.

We haven't decided what our final plans are for the hotel yet. Although most are unaware, the Magnolia Hotel is actually part of the Downtown Historic District. Our dream is to make the bottom floor a full-time history museum, which it deserves. Adding the once elegant balcony where Governor Ireland gave his speech to the crowd when the railroad came to town is number one on our bucket list. In the backyard of the hotel, we would love to reconstruct the 1930s garage once used by Edgar Lannom and add a wishing well in honor of Willie. A few times a year, we delight in offering a free open house to the public. There is nothing we enjoy more than showing off our restoration progress. To us, the Magnolia Hotel is more than just an old building—it is true Texas history just waiting to be told and home to many spirits that we have grown to think of as family.

BIBLIOGRAPHY

Ancestry.com.

Comal County Clerk Archives.

FitzSimon, Father L.J. *Seguin, Texas*. N.p.: Centennial, 1938.

The German Texans. Part of the Institute of Texan Cultures' The Texians and The Texans series by the University of Texan Cultures–San Antonio 1987. Library of Congress number 70-631080.

Gesick, E. John, Jr. *Under the Live Oak Tree: A History of Seguin*. Seguin, TX: Seguin State Bank and Trust Company, 1988.

Gretchen, Mark. *Slave Transactions of Guadalupe County, Texas*. Santa Maria, CA: Janaway Publishing, 2009.

Guadalupe County Clerk Archives.

The Handbook of Texas. https://tshaonline.org/handbook.

Seguin Gazette News.

Seguin Public Library.

Sophienburg Museum and Archives, New Braunfels, Texas.

Weinert, Willie Mae. *An Authentic History of Guadalupe County*. Seguin, TX: Seguin Conservation Society, 1976.

Windle, Janice Woods. *True Women*. N.p.: Ivy Books, 1994.

ABOUT THE AUTHOR

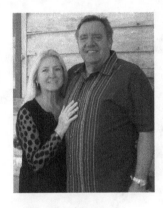

Erin and Jim Ghedi.
Photograph by Megan
Foster, Seguin, Texas,
meganfosterphotography.com.

Erin O. Wallace is married to her high school sweetheart, James "Jimmy" William Ghedi. Erin is a fifth-generation Texan born in San Antonio. She is deeply proud of being a descendant of the famous Texas Ranger William Alexander Anderson "Big Foot" Wallace and Nicolaus Zuercher, one of the founding families of New Braunfels. She attended MacArthur High School in San Antonio before her family transferred to Louisiana. She spent many years in St. Tammany Parish, where she raised her two children, Jennifer and Michael. With her deep passion for history and genealogy, she became a local historian, museum curator, journalist, history editor, published author and an award-winning syndicated genealogical columnist. Her love of history and genealogy were always her first choice of conversation, but speaking of the mysteries of hauntings was never far behind. Being born to a parent with extreme psychic abilities, the supernatural was impossible for her to avoid. Throughout her upbringing, she was involved in her mother's paranormal accounts on a daily basis, making her comfortable around the spirit world. Erin did not acquire her mother's psychic capabilities, but she was blessed with the ability as a medium. This gift and her love for the Magnolia Hotel are the reasons why the spirits have entrusted her with their deepest, darkest secrets.

Visit us at
www.historypress.com
···